THE EARLY IRONWORK
OF CHARLESTON

THE EARLY IRONWORK
OF CHARLESTON

BY

ALSTON DEAS

Illustrated by RICHARD J. BRYAN

Introduction by ALBERT SIMONS, F.A.I.A.

LINDEN PUBLISHING
FRESNO, CALIFORNIA

246897531

THE EARLY IRONWORK OF CHARLESTON
By

Alston Deas

ISBN: 0-941936-38-4

Library of Congress Cataloging-in-Publication Data

Deas, Alston, 1893-1985.
 The early ironwork of Charleston / by Alston Deas ; illustrated by
Richard J. Bryan ; introduction by Albert Simons. -- 1st Linden ed.
 p. cm.
 Reprint. Originally published: Charleston, S.C. : Bostick &
Thornley, 1941.
 Includes bibliographical references and index.
 ISBN 0-941936-38-4
 1. Ironwork--South Carolina--Charleston. I. Title.
NK8212.D43 1997
739.4'7'757915--dc21 97-7738
 CIP

Originally published 1941
First Linden edition 1997
©Linden Publishing Inc.
PRINTED IN THE UNITED STATES OF AMERICA

Linden Publishing
3845 N. Blackstone Ave.
Fresno, CA 93726
1-800-345-4447

To

ALLEN SINKLER DEAS

ACKNOWLEDGMENT

So many individuals have given generously of their time and store of information; so many have kindly permitted the measurement of the ironwork in their possession, that an acknowledgment naming each would cover several pages. Such a list would be too long, but there are certain names which must not be omitted. Expressions of thanks and appreciation are therefore offered to the Misses Ellen M. Fitzsimons, Arabella S. Mazyck and Frances Jervey, of the Charleston Library Society, Elizabeth H. Jervey, of the South Carolina Historical Society, Caroline Sinkler, Alice R. H. Smith, Kate Hammond Price, Susan Pringle Frost and Mary Brewton Frost; also to E. Milby Burton, E. Burnham Chamberlain and Miss Emma B. Richardson, of the Charleston Museum; to E. Prioleau Ravenel, Samuel Gaillard Stoney, Major William S. Lanneau, Lawrence W. Bicaise and the Reverend Merrit F. Williams; to Chapman J. Milling, who read the manuscript and offered valued criticism, Frank E. Seel, who made the detailed measured drawings, and Daniel W. Millsaps, Jr., who helped with the scales and in many other places throughout the book. Grateful acknowledgment is also expressed for the assistance furnished in the past by the late Mrs. Alice Rutledge Felder, Mrs. Louisa Cheves Stoney and Miss Mabel L. Webber. Especially, it is desired to thank William Gordon Belser, Jr., who brought author and publisher together, Albert Simons, who with sound advice and patient instruction served as guide throughout a path strewn with countless pitfalls, and Caroline Pinckney Rutledge, who for many years urged the completion of a work which had been put aside.

Without the drawings of Richard Bryan the book could never have come into existence. To have achieved a delicate balance between architectural draughtsmanship and free hand sketching was difficult in the first instance. To have maintained that balance consistently throughout the entire series, thereby interpreting the very soul of the old wrought iron, was an accomplishment truly remarkable.

INTRODUCTION

For the 1997 Edition of
"The Early Ironwork of Charleston"

Alston Deas (1893-1985) served for sixty years in the United States Army. A graduate of West Point, he saw extended action in the Pacific theater of World War II. Rising ultimately to the rank of Colonel, he was also an educator teaching first at his alma mater and then at The Citadel in his native South Carolina. It was his teaching duties that probably encouraged him to develop a broad range of intellectual interests of the sort which one does not readily expect of a military man. He was, for example, very active in both the Carolina Art Association, the Poetry Society of South Carolina, and was appointed honorary curator at the Charleston Museum. But his deepest and most abiding interest was reserved for historic buildings. He sprung to their defense in Charleston in the 1930s joining the celebrated fight to save the city's noteworthy structures. He would become a charter member of the Foundation for the Preservation of Historic Churches, president of the Society for the Preservation of Old Buildings, and finally serve as chair of the influential Charleston Zoning Commission. He even found the time to raise funds for the restoration of Nagoya Castle in Japan.

Given this background it is easy to see how Deas was inspired to assemble a book on decorative ironwork. His *Early Ironwork of Charleston* combined in one project his interests in art and architecture, southern history, and the cultural achievement of South Carolina. His was the first book on Charleston decorative wrought iron to attempt to do more than merely provide illustrations of gates and grillwork; Deas offered an historical explanation. After carefully sifting the fragmentary record left in surviving written documents, he was able to track down potential sources for early pieces. He then went further to suggest how some of the more spectacular works may have provided the precedent for later commissions. It is for this basic and altogether necessary "detective" work that Deas has earned the lasting respect of scholars and aficionados of early blacksmithing.

INTRODUCTION

Deas limited his inquiry to what might be termed the first period of decorative wrought iron in Charleston extending from the 1750s up to the 1830s. Those wanting to look further into the Charleston saga in iron -- which arguably reached its zenith in the middle decades of the nineteenth century -- could profitably consult other and more recent books. Beatrice St. Julien Ravenel's *Architects of Charleston* (1945) contains useful information on some of the fences and gates that were designed to accompany the city's most prominent buildings. A more complete survey of extant antique ironwork in Charleston can be found in either of two works: Charles Bayless, *Charleston Ironwork: A Photographic Survey* (1987) and Joseph F. Thompson, *Doors and Gates of Charleston* (1991). And finally, John Michael Vlach offers a detailed life history of Charleston's most celebrated living ironworker in *Charleston Blacksmith: The Work of Philip Simmons* (1992). While the publication of these later volumes suggests that public interest in Charleston's ironwork remains quite strong, the reappearance of Deas's book some fifty-five years after its first printing should serve to broaden and deepen this appreciation for the skills of an earlier age.

JOHN MICHAEL VLACH
Washington, D.C.

INTRODUCTION

"It goes without saying that what distinguishes a town from a village is not size, but the presence of a soul." This Spenglerian axiom is especially true of Charleston, a city insignificant in area and population in comparison with scores of the megalopoli of North America, yet one which maintains an importance out of all proportion to its material limitations. The Old World has many towns of this sort, as the names of Chartres, Athens or Damascus come to mind, but in this country they exist only as accidents of fate, and survivals such as Portsmouth, Charleston and Santa Fe are only too rare; landmarks of history that have saved their souls because the past has lived on here and shaped the character of the present.

In Charleston much of this character is enshrined in the presence of a wealth of wrought ironwork which graces old buildings with airy balconies and lacy grilles and gateways half revealing and half concealing sequestered gardens. It is with no great effort of the imagination that one can picture how harsh and prosaic the street scene would be should this enrichment be removed. It would be as disastrous to delete the lyrics from "As You Like It", those grateful emotional holidays in the midst of the business of the plot.

In evaluating the quality of this ironwork we should always be ready to make a distinction between its intrinsic worth as bits of isolated design and its cumulative contribution to the entire scene. Many a grille or bracket will seem naïve in all conscience, yet holds its place admirably in the position in which it is found.

The author has shown commendable self-discipline in selecting only the earlier and more restrained examples, and has steadfastly resisted the meretricious blandishments of later and more florid works. As documents, these selected examples will be of unquestioned value to the architectural designer and will demonstrate how little enrichment will suffice to score an accent of interest, if proportion and interval are judiciously handled. The student of early American crafts will find here a rich vein for his researches and will be fascinated in discovering how the pattern of an elegant communion rail, imported from Eng-

land by pious church wardens, sired in the course of years a varied progeny of balconies and gates throughout the community.

I consider it an auspicious circumstance that this book is not the work of a professional architect, as one might expect, but of a scholarly and appreciative amateur. Is it too much to hope that, despite all the perils and dangers of this night over civilization, we find here and in other kindred efforts of this day an affirmation of a higher level of culture: an acceptance of those standards which prevailed in the days when these fabrics of grace and loveliness were hammered out in modest smithies along with such works of utility as horse-shoes and building nails: a belief in the importance of the rightness of things seen as a part of the rightness of life and the desirability of men with leadership setting an example of good taste and propriety for humbler folk to follow?

In devoting his scanty leisure to the task of mastering the subject of this book the author is but following an earlier American tradition, a tradition which was not beneath the dignity of either Washington or Jefferson, and survived in American culture down to the disruptions of the Confederate War.

The author, as a man of action and affairs deeply engrossed in the complexities and responsibilities of military administration, has brought to this work a fresh and vigorous approach which is stimulating in its enthusiasm and convincing in its sincerity.

Richard Bryan's drawings are not only a delight to the eye but are accurate and dependable interpretations of the examples presented. The subtle variations of freehand pencil drawings are especially sympathetic to the slight irregularities of hand-wrought ironwork.

The publishers have once more earned the gratitude of the public in producing a book of rare distinction and lasting worth.

ALBERT SIMONS.

PART I

I

The early wrought iron of Charleston is English in origin, deriving its inspiration from that of the first three quarters of the 18th century in England. This in turn had flowered through the influence of Daniel Marot and Jean Tijou, who introduced into England the French styles of the period of Louis XIV. Tijou worked in London and at Hampton Court under the patronage of William and Mary and Queen Anne. In addition to the construction undertaken for his royal patrons, he also produced gates and screens for a number of country seats. He was followed by several excellent craftsmen who carried on his work, but in a more restrained manner, transmuting the full-blown baroque of Louis XIV into a truly English style devoid of over-emphasis.[1]

This true English style possesses very definite and unmistakable characteristics, exemplified in the many gates, railings and fences which survive. It is rich, but simple. The gates, set off by pilasters in ironwork, which are repeated at intervals along the fence, are surmounted by an overthrow which tapers upward in an ogee outline pointed at the apex. At the bottom of the gates are bars, often pointed and barbed, to prevent the passage of dogs.[2] [3]

In most of this work there is an appearance of strength and solidity without heaviness. There is a crisp, firm treatment of the husks and water leaves, which are overlaid, and closely attached to the scrolls and uprights from which they issue. Twisted finials and beading are common. Rectangular collars and moulded clips conceal the joints and emphasize the boldness of the design. Fiddle-shaped panel elements and elongated lyres are trimmed with husks, water leaves and tendrils.

Besides gates and fences, there were balconies and balustrades, screens, window grilles, lamp standards, brackets and a great variety of minor pieces. There was much cheerful color, blue or green, set off with gold, in contrast to the dull and uninviting black in vogue at the present time.[4]

[1] Gardner, J. Starkie. English Ironwork of the 17th and 18th Centuries. B. T. Batsford, London [1911]. Pp. 37-59, 63, 72, 81-115.
[2] *Ibid.*, pp. 83, 88, 101, 114.
[3] Goodwin-Smith, R. English Domestic Metal Work. F. Lewis, Leigh-on-Sea, Essex, 1937. Plates II and III.
[4] Gardner, J. Starkie. English Ironwork of the 17th and 18th Centuries. Introduction, p. *xxvii*.

In Charleston, or, as it was then called, Charles Town, where fine houses were already being built early in the 18th Century, the prevailing English forms in architecture, together with the customary accessories in decorative external ironwork, set the fashion, although the provinces tended to lag somewhat behind the mode of the day in the mother country. There were certain concessions to the heat of the sub-tropical climate: a profusion of balconies and, later on, great galleries or piazzas attached to the southern walls of the buildings. Thus, B. Roberts' panorama of June 9, 1739, which was the basis of a number of similar imitative engravings of subsequent years, shows, in its complete picture of the Charles Town water-front from Granville Bastion to the northern limits of the city, one or more balconies on the majority of the houses.

While the scope of the panorama is too broad to disclose such details as the material of which these balconies were constructed, it is probable that there were a few of iron, and a great many of wood. Almost the entire area shown was burned over in the great fire of 1740, which destroyed about three hundred dwelling houses, as well as other buildings. However, the fact that wooden balconies were in general use for a number of years later is clearly established by an item in the *South Carolina Gazette* of November 15, 1760.[5] [6]

Describing the festivities attendant on the celebration of the King's Birthday on Monday, November 10th, the account reads as follows:

"The night was concluded with illuminations &c. &c. But one disagreeable accident happened which was this: a great number of ladies and some gentlemen being assembled at a house on White-Point opposite to Lyttleton's bastion, to see the fire works played off there, and crowding into the balcony, the balcony fell, broke several limbs, and bruised many of the company terribly. *'Tis a wonder that such accidents do not happen more frequently, as scarce any of the balconies in this town are supported with pillars, but rest solely on pieces of timber let into the ends or sides of houses, which rot at the ends let into the houses, being frequently wet with rain and wanting air; this, there is reason to believe, is the state of many things that have been long built, and the above accident ought to be a caution to examine and repair them.*"

[5] *South Carolina Gazette*, Charleston, S. C., November 20, 1740.
[6] Pringle, Robert. Unpublished letter book in the possession of the Misses Susan Pringle Frost and Mary Brewton Frost.

Of the occasional iron balconies which are believed to have been interspersed among the wooden ones prior to the fire of 1740, the railing of but one fine specimen remains (Figure 3). This railing, from which the side members have been removed, is now in the Charleston Museum. With the exception of a few rather naïve and unassuming examples which reflect the work of plain smiths accustomed to produce articles of a strictly utilitarian nature, it is believed to be the only balcony in Charleston of a period considerably earlier than that of the brothers Adam.

No doubt a fair number of iron gates and fences existed before 1740 which were destroyed in that conflagration, as well as a great many which, created subsequently, were destroyed in the fires of 1778 or later years. A certain number must have been melted down for military purposes during the American Revolution; there is a tradition that much of the old wrought iron was used as material for horseshoes for draught and riding animals of the Continental forces. Several wooden gates now in existence are of 18th or early 19th century design, and may well be substitutes for iron ones removed during the struggle.

In a more recent war, ornamental iron work was again sacrificed to military necessity. The following lines explain the circumstances:

"Many years ago, in speaking of the beautiful ironwork in Charleston, my aunt Miss Elizabeth Pinckney Rutledge said that some of the finest gates were given in the sixties to be used for the Ironclad, the supply of iron having given out, and more being needed. She mentioned the ones at her grandmother's house, Mrs. Frederick Rutledge's, on Tradd Street, and said many other handsome ones were sacrificed at the same time, thus accounting for the heavy wooden ones to some of the finest town houses."[7]

Toward the end of the conflict, the scarcity was such that all iron throughout the city not firmly fixed in place was taken up by squads of men detailed for that purpose by representatives of the Confederate government. A time worn cannon from a French privateer, which had lain for many years in State Street as a trade emblem before the shop of Bicaise the gunsmith, was spared by the gang foreman, who was a friend of the proprietor, and kept putting off the seizure of that particular treasure until the war was over.[8]

[7] Felder, Mrs. Alice Rutledge. Unpublished letter in the possession of the author.
[8] Bicaise, Lawrence W. Verbal reminiscences.

Not all of the wrought ironwork of the earliest period disappeared as the result of accident or strict utilitarian demands. Tastes and fashions changed, and an occasional replacement was effected when it was felt that the earlier work had lasted beyond its time.

An interesting illustration of such a change is that relative to the substitution in 1826 of a new fence for the old at the eastern graveyard of St. Philip's, where this fence approached the portals of the church. From an early date the colonists appear to have accepted as a matter of course the grim funereal emblems wrought in the design of the gate, but when, in relinquishing a portion of the yard to the city for the purpose of widening the street, a sufficient sum of money, together with the requisite iron, was furnished by the corporation of Charleston to provide the present "neat iron railing", the substitution was made without recorded reluctance on the part of anyone.[9]

The sombre quality of the old gate has been described by two contemporary anonymous writers:

"Trifling, indeed, must that mind be, which entering its holy walls is not impressed with that religious awe which the motto that formerly stood over its iron gates was well calculated to inspire—*Moriendum est omnibus*." [10]

And again:

"A heavy brick wall, and heavier gate of iron, enclosed the burial place, and were connected with the porticoes. Skulls and crossbones were wrought in the antique iron-work, and formed no unfitting device for such an abiding place. These, however, gave place to a more modern fancy, and a neat iron railing took the place of the heavier wall but a few years ago. By itself the new enclosure was decidedly more agreeable to the eye than the old, but it is very questionable whether it so well accorded with the venerable aspect of the ancient fabric." [11]

Stair railings and porch balustrades were less readily spared than gates and fences, and a number of handsome examples remain, notably as fixtures to houses erected during the great building era which set in at the close of the

[9] St. Philip's Church. Minutes of the Vestry and Wardens, July 8, 1826.
[10] Cromwell, O. Directory of Charleston, 1829, p. 11.
[11] Southern Literary Journal, Charleston, S. C., January, 1836. Vol. I, Number 5, p. 365.

French and Indian War, and continued until the period of the American Revolution.[12]

The best of these balustrades are severely plain, extending across the entire width of the porch, then sweeping in a curve or at right angles along the edges of the steps and landings. The severity of the whole is relieved by central and side panels of exquisite design so quietly placed as to exert a subtle appeal not obvious at first glance. This subtlety is one of the outstanding characteristics of the greater part of the early wrought iron. There is nothing flaunting or grandiose about it, and the finest pieces in the city are sometimes overlooked by the visitor, who is apt to admire unduly the relatively inferior, but far more conspicuous products of a later date.

In 1772 there was imported from England a small railing, the design of which, a wholly conventional one of the period, must certainly have exercised a strong influence upon the local smiths. Variations of the pattern are to be noted in one form or another in much of the work of the day, and even down to the third decade of the 20th century. This railing was the chancel or communion rail of St. Michael's Church (Figure 8). It was ordered along with other accessories and, although an outstanding and beautiful example of craftsmanship, would seem, from the minutes of the vestry below quoted, to have been of a relatively low cost.

"The Warden inform'd the Vestry that the Surplus Subscription in his Hands after paying for finishing the Altar Piece, & Painting the Galleries Amounted to Upwards of Three Hundred & Fifty pounds, they therefore agreed that as he proposed embarking for England in April next, that the sum of Fifty Pounds Sterling shou'd be sent by him for the Purpose of Purchasing an Iron Rail for the Altar agreeable to dimensions to be given in by Mr. Benj. Baker, also for Crimson Indian Damask Curtains for the Organ Gallery, to run upon Brass Rods & Rings Lacquered, agreeable to Instructions from Mr. Baker, to have (if within the Compass of the above £50) a Gold Fringe Border, and double Gilt Pine Apple Tops at each end or some such like ornaments, but shou'd the Monies prove insufficient for these Purposes, then to have only a plain Silk Fringe Border." The Indian Damask Curtains have gone into

[12] Simons, Albert, A. I. A., and Lapham, Samuel, Jr., A. I. A. Charleston, South Carolina. Press of the American Institute of Architects, Inc., New York, 1927. Pp. 22 and 23.

dust, but the rail, in spite of wars and hurricanes, still serves its purpose for devout communicants.[13]

This communion rail, which is believed to have exerted so strong an influence upon the work of provincial smiths and their successors, while possessing all of the characteristics of the best English work of the third quarter of the 18th century, is fortunately devoid of the profuse ornamentation with which the more ambitious English pieces are overlaid. It is so simple as to be readily copied, with such modifications as might seem desirable. It sets a standard within the reach of the Charleston ironworker, with his limited tools and experience, a standard to which he was able to attain, without falling into faults of design and construction. Thus, there are no florid acanthus leaves, no vines, or berries, or elaborate heraldic devices. The whole rail is of good, honest, solid design and construction, and in the best of taste; quiet and unobtrusive, but so well conceived and executed as to stimulate the imagination and set the standard for a whole generation of ironworkers. Whatever pattern books were available to the local smiths, it may well be supposed that the influence of this design, or of similar pieces which have by now disappeared, was exerted in the forging of the balcony from Number 87 East Bay (Figure 15), the portal gates of St. Philip's (Figure 10), and dozens of grilles, gates and fences which have long since disappeared, as well as many more which yet remain.

In the 1770's a change in architectural style began to make itself felt. Robert Adam, the great Scottish architect, had published his celebrated book "The Ruins of the Palace of Diocletian" in 1764, and, although it must have been purchased by members of one or more of the great planter families of the colonies, no immediate change in Charleston architecture seems to have resulted from its appearance. However, after Adam had associated himself in business with his brothers, and they commenced the publication in 1773 of their series of folio engravings and descriptions of the designs for many of their most important architectural works, the new taste which they introduced began to make itself everywhere apparent in the more prosperous communities both of England and her distant provinces.[14] [15]

[13] St. Michael's Church. Minutes of the Vestry and Wardens, March 23, 1772.
[14] Dictionary of National Biography, Oxford University Press, 1917. Volume I, pp. 83-84.
[15] Simons, Albert, A. I. A., and Lapham, Samuel, Jr., A. I. A. Charleston, South Carolina. Pp. 102-104.

The Adam style, as it came to be interpreted in Charleston, is characterized by a lighter and more delicate design than had been the fashion in the earlier provincial period. Just as the earlier solemn and dignified style of such fine old homes in the vicinity of the city as Fenwick and Drayton Halls (there are none of the period of corresponding worth yet remaining in Charleston), gave way to such examples, equally dignified, but far more livable, as the Miles Brewton, John Stuart and John Edwards houses, so these in turn yielded in popular taste to a design felt to be lighter and more graceful still. In this there is much delicate reeding and applied putty work in the interiors, and slender columns, graceful fanlights and airy balconies on the exteriors. The new architecture, although deriving from the monuments of antiquity, possessed qualities peculiarly its own, and was far removed from the cold formalism of the later so-called Classic Revival.[16] [17]

Although the Adam style probably gained a foothold in Charleston in the early 1770's, the interruption to building resulting from the Revolutionary War prevented its rapid spread until the return of prosperity some time after the struggle, when numerous structures in the new manner were erected. The fire of 1778, which destroyed a considerable part of the oldest quarter of the city, made room for much new construction. Certain fine houses, for example, that of William Gibbes, on South Battery, which had been built a number of years before, were adorned with new decoration curiously combined with the old. Adam door frames and cornices surround, without replacing, the originals, mantel pieces with classic reliefs in putty are substituted for the older ones of carved wood. The central panel of the wrought iron porch balustrade of the colonial era is cut away, and an ornamental panel of a handsome, but utterly different design, inserted (Figure 20). A pair of lantern standards has been added above the decorative panels near the end, but these panels themselves have not been changed. To complete the curious combination of old and new, the iron terminals of the old newel posts are removed, and brass urns of the Adam

[16] The works in Architecture of Robert and James Adam. Facsimile reproductions of plates. John Tiranti and Company, London.
[17] Simons, Albert, A. I. A., and Lapham, Samuel, Jr., A. I. A. Charleston, South Carolina. Pp. 103 and 104.

period attached in their stead, although the earlier twisted newels are themselves retained. (Figure 23.) [18]

The ironwork of the new period is definitely in keeping with the buildings it adorns, being light, graceful and delicate in appearance. Most of the examples still extant consist of balconies, balustrades, passageway lunettes and window grilles. Fine wrought iron gates of the Adam period seem not to have been made in any considerable number, even in England, and there are practically none at all in Charleston. There are, however, a few lantern standards. In this connection, it is interesting to note that when the standards of the Adelphi, at No. 13 John Street, designed about 1773 by the brothers Adam, were removed during the extensive London remodelling of the 1920's, one member of this famous pair was purchased by the late Isaac E. Emerson, who placed it at the landing of the back steps to Prospect Hill, the old house of Thomas Allston on the Waccamaw River, near Georgetown. With such a model at hand as an inspiration a century and a half ago, how much greater a quantity of excellent work must have been wrought by the Charleston craftsmen! [19] [20].

In the period between that of the old established order of architecture and the era of the brothers Adam—say in the early 1770's—there appears a certain amount of ironwork partaking of the styles of both. For instance, in the handsome balcony now adorning the old house of Henry Middleton on South Battery, and which formerly was affixed to 87 East Bay, there is a central panel bearing a marked resemblance to the gate panel of St. Michael's communion rail and that of St. Philip's portal gates, and which seems almost beyond the shadow of a doubt to derive its inspiration from one or both of these pieces, or from a common basic pattern. Yet on either side are scrolled balusters which foreshadow the type soon to be found in nearly every good Charleston balcony of the Adam period (Figure 19). Similarly, in the balcony at the corner of Broad and Church Streets, delicate balusters and graceful naturalistic flowers are set between sturdy twisted posts with iron balls atop, which belong very definitely to the fashion just going out (Figure 20).

It is a matter of interest to note that in these two houses, the interior of the

[18] *Ibid*. Pp. 102-104.
[19] Inscription on plate at base of standard.
[20] Gardner, J. Starkie. English Ironwork of the 17th and 18th Centuries. Pp. 172, 260 and 280.

first is of the Adam style, with putty ornamentation and reeded woodwork, and that of the second Georgian, with the bold, vigorous carving of the earlier order. The fashions definitely overlap.

The greatest Charleston exponent of the Adam style was Gabriel Manigault, a member of the distinguished French Huguenot family of that name, who left the imprint of his keen and discerning taste upon several of the best public and private buildings in Charleston. He designed the City Hall (built in 1801 as the Bank of the United States); the chapel of the Charleston Orphan House; his own home, demolished in recent years; and that of his brother Joseph. This last is widely conceded to be one of the outstanding examples in the United States of domestic architecture of the period.[21] [22] [23]

Fortunately, the date of construction of most of the work known to have been designed by Manigault is a matter of record, and the student may as a result establish, by comparison with the ironwork adorning his buildings, the period in which similar pieces were made. He did not use much decorative iron, but all that he did use was good. There was a landing balustrade, together with stair railing, in front of his own home, built in 1796 at the corner of George and Meeting Streets. The pattern of the central panel is repeated nearly line for line in at least three other railings of the city; in the balustrade of the William Gibbes house on South Battery, and in two balconies, one on a house in Church Street, near Tradd, and another, now in the Charleston Museum, from a house formerly standing in Broad Street, near Church.[24] [25]

The circular basement windows on the front and sides of the City Hall are grilled with concentric circles separated by scrolls within the space between the outer and inner circumferences (Figures 41 and 42). Outlined petals radiate from a cast boss at the center to the ring of the inner circle. The arched basement windows to the rear are protected by grilles in which is wrought a modification of the anthemion, or Greek honeysuckle. The anthemion had been a favorite decorative motif in England from the early years of the Adam period,

[21] Simons, Albert, A. I. A., and Lapham, Samuel, Jr., A. I. A. Charleston, South Carolina. P. 103.

[22] Smith, Alice R. Huger and D. E. Huger. The Dwelling Houses of Charleston, South Carolina. J. B. Lippincott, Philadelphia, 1917. Pp. 134 and 192.

[23] Manigault Family Record. Unpublished manuscript in the Charleston Museum.

[24] Holmes, Mrs. A. J. C. Unpublished letter in the possession of the author.

[25] Photographs in the possession of the Society for the Preservation of Old Dwellings, Charleston, South Carolina.

but, curiously enough, did not come into extensive use in Charleston ironwork until the period of the Classic Revival, and then in cast, rather than wrought iron. The lamp standards of the Adelphi, previously spoken of, incorporate this anthemion in a fine triple arrangement, the conventionalized flowers placed one above the other in gradually diminishing size from base to apex. The finest wrought iron of any of Manigault's buildings is that of the South Carolina Society Hall, built in 1804. The stair rail, of which the panels display a continuously repeated design of upright elongated S scrolls, with husks in pairs breaking from the scroll just above the center, is reminiscent of staircase railings of the period in the great London houses, but possesses a greater strength and vigor better suited to its outdoor situation (Figure 39). The lantern standards at the foot of the steps are of a much earlier style than that of the rail itself. In this case, otherwise than in the balustrade of the Gibbes house, the rail is cut away to make room for an accessory element, older, instead of newer than the building.

Handsome as this stair railing is, it is equalled, if not surpassed in quality, by the basement fanlight, which covers the window on the lower landing (Figure 40). The pattern has been reduced to the absolute minimum of simplicity; it possesses little more than the bare requirements of structural necessity, but in utter purity and restraint, in contrast with the rich strength of the stair panels, it stands alone.

There were other excellent fanlights or lunettes of this period, and many fine grilles for rectangular windows. A number may still be seen in their original settings, or displayed in the Charleston Museum. As has been said, there are few gates. Only a small proportion yet exists of the former large quantity of signs and sign supports; a very few (and these inferior, and later specimens) of the awning supports which once existed in profusion. There are numerous examples of minor work, such as foot scrapers and shutter guards, and, within doors, an occasional ornamental shelf bracket. In rare instances there are interior stair rails with wrought iron or cast iron balusters.

The outstanding feature of the wrought ironwork of the period in Charleston, and even in England itself, where the sun is far less ardent, is the balcony. Only a few dozen remain of the hundreds which once adorned these old houses, but there are enough to give the city a foreign and an ancient look, which

Charles Fraser, Charleston's eminent painter of miniatures, recorded as long ago as 1854. Nearly all of the best balconies reflect the taste of the Adam period. The best are fine indeed, and even the less successful rise above the mediocre.[26][27]

These balconies are mostly variations of one general theme; plain, sturdy frames, with bars to hold the floor boards, and slender balusters from which scrolls, usually in pairs, break away at the top and bottom, and sometimes at the center as well. Lozenges are sometimes substituted for the center scrolls, or the balusters are pierced to permit the attachment of a lead rosette, round, oval, or flower shaped. Sometimes the balusters continue across the face of the balcony without interruption; again there is a lyre, or an urn, or occasionally a cartouche with the cipher of the owner. The supporting brackets vary from those with perfectly plain curves or straight lines to elaborate scrolls in a multiplicity of designs, and would seem to have afforded an escape from the almost monotonous regularity which was imposed by fashion upon the style of the balcony itself.

Graceful work of this sort is thought to have continued into the second decade of the nineteenth century, some years after the vogue for Adam architecture had subsided in London. By this time, however, a reaction against light design was setting in, a prelude to the introduction of massive edifices copied from ancient temples, which were soon to be erected as homes, churches and public buildings. The new note was struck in a number of gates and fences which, though losing nothing in elegance, were perhaps in greater harmony with the planes and masses of the new structures.[28]

Particularly interesting in this respect are the fences of the First Presbyterian, or "Scotch" Church, the St. Andrew's Society and the First Baptist Church (Figures 48, 49 and 50). The first of these churches was built in 1814, and the second, designed by the famous Robert Mills, in 1822. Bids for construction of the fence of the St. Andrew's Society were called for by newspaper advertisement in 1819. This fence, of a fine, strong pattern of spears and bars, fits well into the category of design of the period just going out, while partaking

[26] Fraser, Charles. Reminiscences of Charleston, John Russell, Charleston, 1854. P. 34.
[27] Gardner, J. Starkie. English Ironwork of the 17th and 18th Centuries. P. 260.
[28] Simons, Albert, A. I. A., and Lapham, Samuel, Jr., A. I. A. Charleston, South Carolina. Pp. 104 and 176.

of the solidity deeemed appropriate for classical buildings. That of the First Presbyterian Church is an excellent example of strength of material combined with delicacy of outline. It bridges successfully the gap between the old fashion and the new, and foreshadows the more modern style of work in the fence of the First Baptist Church.[29] [30]

The period of early ironwork, with its own definite characteristics and impulses, came to an end about this time. There was no break in continuity between the design and construction of the early work and that which now became the fashion, but rather an overlapping, exemplified in a number of porch balustrades still in existence. This volume is concerned with the early work, and makes no attempt to cover the new, but the outstanding characteristics of the latter may be briefly summarized.

It would be arbitrary to attempt to assign an exact date for its initial appearance, although the elaborate gates and fence of St. John's Lutheran Church, set up in 1822, may be considered as establishing in many respects a precedent for much of the work which followed. The workmanship of these gates is better than the design, particularly of the overthrow, which is too large, over-elaborate and lacking in coherence. The overthrows to the gates of the City Hall Park (Washington Square) erected in 1824, and those of St. Philip's eastern churchyard, erected in 1826, while of a different design, are similarly out of proportion, although valuable and handsome examples of the technical skill of the makers.[31] [32] [33]

The new work, while deriving its inspiration from the old, and continuing with it side by side for several years, until it had supplanted it, gradually departed so far from the original models as to establish a style of its own. The designs, after passing through the first experimental stages in which faulty proportion is noted, eventually settled into certain conventional forms more satisfactory in balance. If studied apart from their settings, the design of these might seem to be a little monotonous, but placed as they are among mellow-toned brick walls, shuttered windows, bright or shadowed gardens, and

[29] *Ibid.* P. 174 and Plate, First Presbyterian Church.
[30] *Charleston Courier*, January 1, 1819.
[31] *City Gazette* and *Commercial Daily Advertiser*, Charleston, South Carolina, November 18, 1824.
[32] St. Philip's Church. Minutes of the Vestry and Wardens, July 9, 1826.
[33] St. John's Lutheran Church. Minutes of the Vestry and Wardens, January 14, 1823.

columned piazzas stretching away at different angles from the street, they present a continuously pleasing sense of variety.[84]

The workmanship is more mechanical than that of early days. The iron used, obtainable in a greater number of standard sizes, and therefore permitting many more short cuts than formerly, has lost its interesting individual, beaten, hand wrought look. There is little use of rounded members, or of moulded ones, which were made by placing the hot metal between top and bottom tools known as swages, and shaping it with heavy sledge hammer blows. Beading and collaring are rare, and the husks are often thin and weak. The effect of the whole is good, and much of it deserves high praise, but it lacks the vital, robust, sophisticated tone of the 18th and early years of the 19th centuries, and must be placed within a category of craftsmanship altogether different from that of the early work.

[84] Simons, Albert, A. I. A., and Lapham, Samuel, Jr., A. I. A. Charleston, South Carolina. P. 176.

PART II

Diligent search has failed to reveal which of the many smiths who plied their trade in Charleston during the 18th century and the first two decades of the 19th executed any particular pieces of importance. Of their successors during the 19th and the early years of the 20th centuries much is known, and several fences, gates and grilles can be identified both as to the date and name of maker.

The earliest blacksmith's notice appearing in a Charleston newspaper is that of Thomas Lovelace, who advertises as follows in the *South Carolina Gazette* of March 25, 1732:

"Blacksmiths Tools of all Sorts, and Iron belonging to a Blacksmiths Shop, will be sold on the 25th of next month, one half for ready Money, and the other for 6 Months Credit on good security. Also a white Servant Man a Blacksmith, having 2 years and odd Days to serve, being an able workman, by THOMAS LOVELACE."

The indentured servant went with the equipment of the shop. Black helpers as well as white, were common, and performed their share in producing the many articles of everyday use demanded of the local smiths. The old records of St. Philip's Church record payments for "iron work to the Church bell," for "making stocks," for a "Trammell and 2 Pot Hooks," for erecting "lighning points on steeple," and repairing and regilding the weather cock.[35]

An interesting advertisement of 1753 specifically mentions ornamental ironwork:

"JAMES LINGARD, Smith and Farrier, makes all kinds of scroll work for grates and stair cases; ship, jack, and lock work, and all other kinds of smith's work at his shop on Mr. *Maine's* (commonly called *Frankland* or *Sinclair's*) wharf. Gentlemen that employ him, may depend on having their business done to satisfaction, with all possible despatch, and at the most reasonable rates.—*N. B.*—He will take care of gentlemen's horses, and see that they have good care in case of sickness. JAMES LINGARD." The grates mentioned were probably window grilles.[36]

[35] St. Philip's Church. Minutes of the Vestry and Wardens, 1734, 1738 and 1753.
[36] *South Carolina Gazette*, May 21, 1753.

Gazettes, wills, conveyances and, later on, directories, mention a large number of blacksmiths by name. There is also frequent reference to workers in other metals, notably whitesmiths (tinners) and brass founders. It was not unusual for their shops to be located on wharves, as in the advertisement quoted, probably both as a convenience to water transportation and because of the reduced fire hazard.

Swedish iron is advertised from the earliest issues of the *Gazette* down to the present day. It is listed among the miscellany of imported goods offered by Jenys and Baker on October 7, 1732, and from time to time thereafter. On November 19, 1763, Robertson, Jamieson and Company offer "Exceeding good Swedish bar iron * * * just imported and to be sold on the lowest terms."

Swedish iron then, as now, was considered the most desirable for any work other than casting; for the latter a lower grade was employed. It has the lowest carbon content, is easier to work, is tougher, and the least susceptible to rust of any iron used. These qualities are a result in part of the low carbon content, and also of the great amount of hammering which was required to bring the bars to the proper size, and which gave it a close, tight grain impervious to the weather over a long period of years.[37] [38]

The best known Charleston smiths of the period immediately preceding the American Revolution were the patriots Tunis Tebout and William Johnson. Tebout died at Beaufort during the course of the conflict. Johnson, a man of intelligence and influence, and a leader in the movement for American Independence, survived the struggle, and continued his business for many years thereafter.[39] [40] [41]

Tebout and Johnson at first operated independently, went into partnership in 1765, and by February 23, 1769 once more conducted separate businesses. Johnson's advertisement on the occasion of resuming his individual establishment indicates a wide range of ironwork activities; it is a matter of record that his business was extensive and successful.[42]

[37] *News and Courier*, Charleston, South Carolina, February 11, 1939.

[38] Gardner, J. Starkie. English Ironwork of the 17th and 18th Centuries. Introduction. P. *xxxiv*.

[39] South Carolina Historical and Genealogical Magazine, Charleston, S. C., October, 1916, Volume XVII. P. 154.

[40] Johnson, Joseph. Traditions and Reminiscences of the American Revolution in the South. Walker and James, Charleston, 1851. Pp. 30, 31, 377-387.

[41] *City Gazette* and *Commercial Daily Advertiser*, April 18, 1818.

[42] *South Carolina Gazette*, August 10, 1765 and February 23, 1769.

"William Johnson

Having taken a convenient Shop, on Mr. Charles Elliot's wharf:

Acquaints all his Friends, Merchants, Ship Masters, Planters, and others,

that may have occasion for any kind of

Blacksmith's work,

that they may depend upon the same being done, at his Shop,

exactly agreeable to directions, with the greatest dispatch,

and upon reasonable terms * * *"

Both Johnson and Tebout did much ironwork for the Continental forces.[43][44]

It is not known with certainty what patterns for ornamental work were used by the early smiths, but there must have been plenty at hand. We know from existing records that the communion rail at St. Michael's Church was here as a source of study of excellent English forms. There were probably several manuals available, as well. In the Charleston Library Society is an old pamphlet of plates entitled

"The Smith's Right Hand

or a

Complete Guide

to the

various Branches of all sorts of Iron Work

Divided into Three Parts"

The Drawings are by "Messrs. W. and J. Welldon, Smiths."

This pamphlet was printed for Henry Webley, in Holburn, near Chancery Lane, London, in 1765. It depicts gates, fences, brackets, balconies and stair-case railings, as well as "Lanthorn irons" and "Chandelier irons." One of the grilles bears a fair similarity to one on East Bay in Charleston, and a balcony design contains features to be found both in the balcony formerly at 87 East Bay and in the rail at St. Michael's.

If there was one such pattern book, there must have been others, which

[43] Salley, A. S., Jr. Stub-Entries to Indents for Revolutionary Claims. The State Company, Columbia, South Carolina, 1915. P. 98.

[44] Johnson, Joseph. Traditions and Reminiscences of the American Revolution in the South. P. 30.

furnished designs to be copied outright or modified by the smith at will. The writer has on numerous occasions visited the shop of the last ironworkers of the Ortmann family and watched experiments with designs chalked on the floor a short distance from the forge. The smith would copy the design from this outline, pausing from time to time to check his scrolls against the chalked pattern.

When railings or other pieces of ironwork which were an essential part of the design of a house or public building were involved, the architect himself must necessarily have furnished the broad plan, although it seems likely that in many instances decorative details were left to the fancy of the smith. Gabriel Manigault's work may be an exception; he is thought to have given careful attention to much of the detailed design in his buildings and the ornamental iron would not have been neglected. It would be a privilege to examine the architectural books studied by this distinguished amateur, but these are said to have been acquired by a local antique dealer a few years ago and sold out of the city.

Although a description of the later ironwork of Charleston, which may be said to have been ushered in with the construction of the gates and fences of St. John's Lutheran Church, is beyond the scope of this volume, nevertheless a few words on the subject are appropriate.

The St. John's ironwork was designed by A. P. Reeves, an architect and a member of the congregation. M. Muggridge, J. Jamieson and Company, Thomas Muggridge, D. P. Bingley, Cross and Poincignon, and Jacob Frederick Roh, all of them smiths listed in the Charleston directories of the period, submitted estimates for its construction. Roh, like the architect a member of the congregation, submitted the lowest bid and received the contract, but lost money on the job, and subsequently petitioned the vestry for an additional amount. He made the gates in 1822, employing the labor of himself and eight hands, and received $2,735.13 for the work.[45]

The 19th century Charleston wrought iron workers best remembered today are J. A. W. Iusti, Christopher Werner and Frederick Julius Ortmann, although there were many others who executed equally creditable work. These three, although Germans, performed work along modified English lines.

The handsome gates at St. Michael's Church Yard are Iusti's most famous

[45] St. John's Lutheran Church. Minutes of the Vestry and Wardens, January 11, 1822, January 25, 1822, January 14, 1823 and February 5, 1823.

accomplishment, and are signed on the overthrow in cast letters "A. Iusti, Fecit, Charleston, S. C." Another of his signed pieces is the pavement grille formerly set before Panknin's Drug Store in Meeting Street, and which may now be seen in the Charleston Museum. The name of the proprietor is incorporated in wrought letters. The work is dated 1848.

Iusti performed other work besides the forging of ornamental iron. In the directory of 1880 he is listed as a gunsmith, and in that of 1882 as a steel and brass worker. An accomplished gun and locksmith still living once had him in his employ, and remembers him as an able man handy at cutting and drilling steel and iron. The same authority recalls that Iusti invented an automatic valve in the days when cisterns supplied the inhabitants of Charleston with water for drinking purposes. This valve, which was attached to the gutter-spouts, would divert the first flow of water from the roof until a sufficient amount had run off to insure cleanliness, and would then automatically switch to permit the passage of the fresh water into the cistern.[46]

Christopher Werner, who executed a vast amount of wrought and cast iron work during the period from the 1840's to the 1870's, is famous for such popular creations as the Palmetto Tree, of iron, copper and brass, in the grounds of the State House at Columbia, South Carolina, and the "Sword Gates" in ·Legaré Street in Charleston. He made the fine fence formerly at the Gabriel Manigault House in Meeting Street, now near the lower end of the same street, and is thought to have executed the fence to the Hibernian Hall, with the harp of Ireland wrought in the overthrow; also that of the William Aiken house in King Street, now in the Garden Walk between King and Meeting, and the fence and stair rail of the Elias Vanderhorst house at the corner of Chapel and Alexander Streets.[47] [48] [49]

The "Sword Gates," which owe much of their quality to their setting—the overthrow, with its octagonal lantern, the high brick wall and posts, and the great, empty garden within—are said to have been a part of the grille work ordered for the New Guard House in 1838, and rejected as having been in excess of the amount contracted for. The plan of the Guard House, which build-

[46] Bicaise, Lawrence W. Verbal reminiscences.
[47] *News and Courier*, June 14, 1875.
[48] Holmes, Mrs. A. J. C. Unpublished letter in the possession of the author.
[49] *Charleston Courier*, May 22, 1839.

ing was subsequently ruined in the earthquake of 1886, was furnished by one "Mr. Reichardt," who in all probability designed the grilles and gates as well, with their martial accent of spears and Roman swords. The construction of the ironwork, however, was executed by Werner. After the earthquake the window grilles of the ruined buildings were removed to the police barracks at Marion Square, which were later turned over to The Citadel. When the college was moved to its present location in the northern part of the city in 1922, the grilles were again taken from their setting, and some of them incorporated in the windows of the new gymnasium.[50][51][52][53]

These grilles, of which the panels of the Sword Gates are a slightly larger variation, are, like the gates, of flimsy material, the spear shafts being purely decorative, rather than functional, and the husks which break out from the shafts thin and fragile. The design, too, is faulty, with a poor arrangement of curves. Despite these inadequacies however, the effect of the whole is impressive.

Frederick Julius Ortmann, whose sons carried on his business until a few years ago, executed gates and fences in profusion throughout the city. His best known and most pleasing design is a conventionalized lyre. A well preserved example of gates in which this design is employed may be seen at 34 Broad Street. These gates were made about 1880, and record the model which was used in the greater part of subsequent work of the sort.[54]

The lyre, in different styles, and in varying degrees of workmanship, is one of the best known of the Charleston patterns. As interpreted by the Ortmanns it may be thought to be a link in a long chain of design extending back through a century and a half to the balustrade of the John Edwards house and the communion rail of St. Michael's Church.

The ironworker's craft has not died out today, although the design properly comes within the province of the architect, rather than being left to the ingenuity of the smith. The taste for wrought iron is firmly implanted in the city's inhabitants, and new balconies, window grilles and gates are still in demand, to take their places among the old, and, like these, to become, with the passage of time, a part of Charleston's great artistic heritage.

[50] *Ibid.*
[51] *Charleston Courier*, February 26, 1838.
[52] *News and Courier*, September 3, 1886.
[53] Johnson, George W. Verbal reminiscences.
[54] *News and Courier*, February 11, 1939.

PART III

FIGURE 1. BALCONY, CHURCH STREET, BETWEEN BROAD AND CHALMERS

This balcony, of simple design and crude workmanship, is believed to be one of the earliest examples of wrought ironwork yet remaining in the city.

The handrail consists of a single flat member through which the riveted ends of the balusters protrude slightly. The balusters are square in cross section. The supports, three in number, are plain twisted bars.

FIGURE 2. BALCONY, QUEEN STREET, NEAR CHURCH

Another early example.

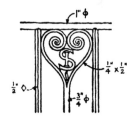

The balusters, except that at the center, are square in cross-section and are set edgewise to the front. The center baluster and handrail are rounded. The cypher of the original owner is wrought below a pair of converging scrolls in the center baluster. This small decorative element lightens the design of the whole, which is otherwise severely plain. The two supports are straight bars terminating in a simple scroll at each end.

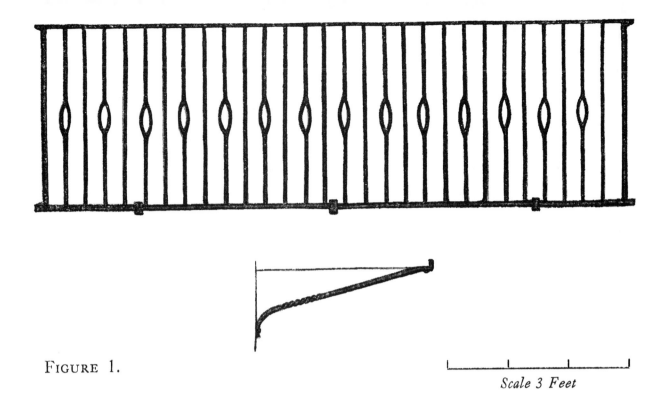

FIGURE 1.

Scale 3 Feet

FIGURE 2.

Scale 3 Feet

FIGURE 3. BALCONY RAIL, CHARLESTON MUSEUM

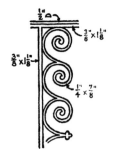

This sophisticated piece is of 17th century design, although probably of early 18th century workmanship. It was formerly attached to an unimportant and relatively modern building in the business section of the city, to which it is thought to have been removed from a much older structure.

FIGURE 3.

Scale 18 Inches

FIGURE 4. LANTERN STANDARD, SOUTH CAROLINA SOCIETY
 HALL

This fine standard is one of a pair at the lower ends of the stair rails of the South Carolina Society Hall, replacing the original newels, which have been cut away to permit the substitution of these pieces, of a style far antedating the period of the building.

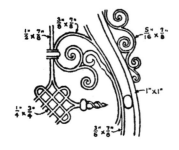

They resemble similar standards produced in England in the 1740's. Allowing for the usual lag in styles in the colonies, this could place the date of their construction as late as 1760 or 1770. Their imposing design indicates that they formerly adorned some public building or home of distinction; possibly they belonged to this same society before the present hall was erected. The destruction of the records of the society in Columbia, in 1865, makes it impossible to determine their origin with certainty.

The lantern is of tin, ornamented with cast rosettes.

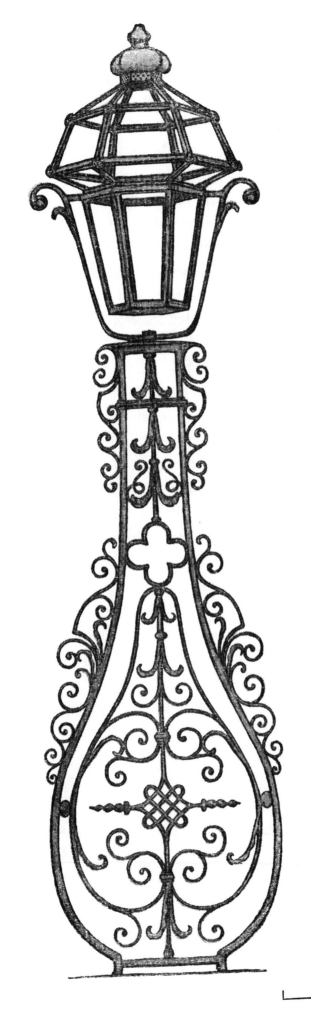

FIGURE 4.

Scale 2 Feet

FIGURE 5. GATEWAY, MILES BREWTON HOUSE, KING STREET

This gateway leads to the forecourt of the house in lower King Street, built during the second half of the 1760's by Miles Brewton, a noted merchant and social figure in the years immediately preceding the American Revolution. The owner, with his entire immediate family, was lost at sea not long after the house

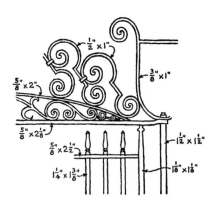

was completed, and it was inherited by his sister, the celebrated Revolutionary heroine, Rebecca Motte. She was living here when the house was occupied as his headquarters by the English general, Sir Henry Clinton.[55][56]

The architect, who also carved the woodwork of the panelled interior and the external frieze, was Ezra Waite. Whether or not he designed the ironwork is unknown.[57]

This gateway is the solitary remaining example in the city of early work in which the overthrow is employed, the only other gate thought to be of the period being that of the western churchyard of St. Philip's, which, though richly elaborate in its central panel, is devoid of ornamentation at the top. The Miles Brewton gates are themselves perfectly simple, consisting of moulded pickets and lock rail, set in their stile, or frame. The pickets of the gates and fence resemble exactly those of many 18th century London fences.

The large baroque shell at the center of the overthrow rises above a flat lunette filled with C and S scrolls, decorated with husks and terminating at the outer ends in tendrils, and is braced with a series of broken scrolls collared together. An applied ornament at the base of the shell has long since rotted; a fragment which remains, grooved and curving outward, indicates that it was once an acanthus leaf.

The lantern supports are simple scrolls, supporting hexagonal lantern rings. The lanterns are of tin, and are copies of the originals, which, though still in existence, have rusted to such an extent as to be unfit for further use.

A heavy iron chevaux-de-frise, said to have been attached to the fence and gate after the attempted servile insurrection of 1822, is not shown in this illustration. It detracts from the design, and is of interest only as a curiosity.

[55] Ravenel, Mrs. St. Julien. Charleston, the Place and the People. The MacMillan Company, New York, 1929. P. 276.
[56] Smith, Alice R. Huger and D. E. Huger. The Dwelling Houses of Charleston, South Carolina. Pp. 93 and 100.
[57] Ibid. Pp. 94 and 99.

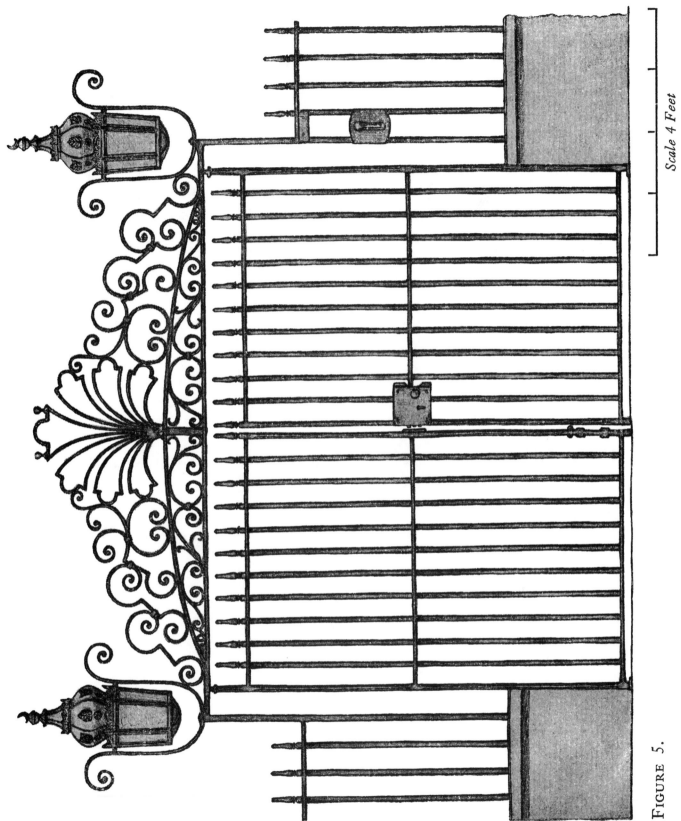

Scale 4 Feet

FIGURE 5.

FIGURE 6. FENCE POSTS AND PICKETS, MILES BREWTON
HOUSE

The fence consists of six panels of pickets, separated by cast posts capped with flaming urns.

The pickets are similar to those of the gates, but are shorter. Together with the posts, they are set in a coping of silver stone on a low stuccoed brick wall.

FIGURE 7. SIDE VIEW, GATE BRACES AND LANTERN, MILES
BREWTON HOUSE

The gates are braced by tall, plain bars set in the stone pavement.

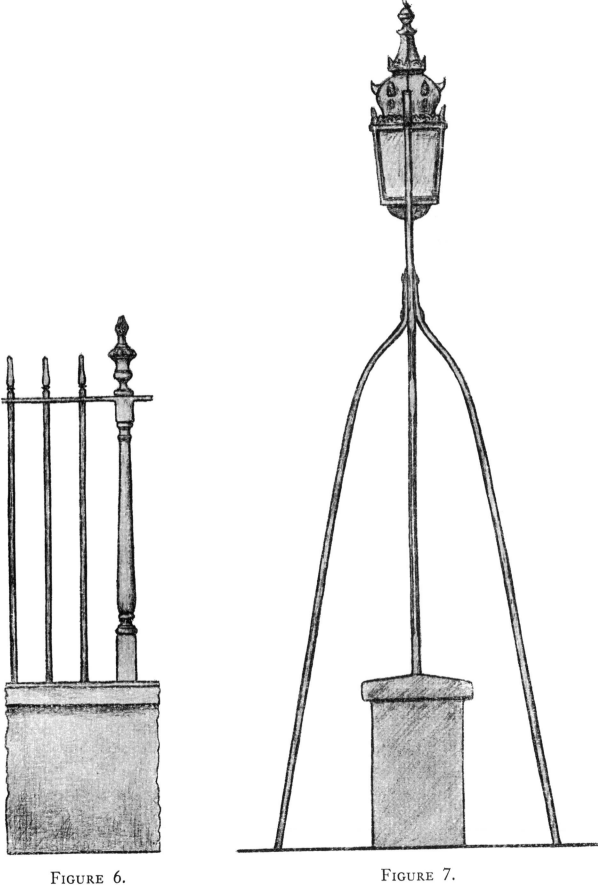

FIGURE 6.

FIGURE 7.

Scale 3 Feet

FIGURE 8. COMMUNION, OR ALTAR RAIL, ST. MICHAEL'S CHURCH

Reference has been made in the text to the Communion Rail of St. Michael's, which was ordered from England in 1772.

It consists of two sections, one on either side of a pair of center gates.

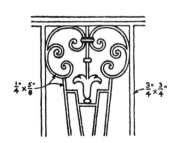

One of these gates, together with the next two adjacent units, is shown in the illustration. The left unit shown, that next to the gate, is fiddle-shaped, and is succeeded to the right by four of lyre shape, after which the design of the first is repeated in a single unit at the far end. There is thus, in the entire rail, a total of four of the first and eight of the second, besides the gates themselves.

Both pattern and workmanship are of the highest quality, having been executed by competent craftsmen at a time when English wrought ironwork was in full flower. Mention has already been made of the influence which the rail is believed to have exerted upon the work of the Charleston smiths.

The whole is gilded and is capped with a hand rail of wood, mahogany in one place, and pine, possibly a replacement, painted to resemble mahogany, in another.

FIGURE 8.

Scale 18 Inches

FIGURE 9. WINDOW GRILLE, EAST BAY

The grille illustrated is one of a set attached to the window casings of an old mercantile building on East Bay. Unlike many others, it projects slightly beyond and away from the window it screens.

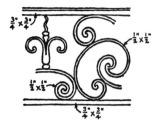

The free and open design is particularly pleasing and harmonious. The scrolls are so flat in treatment as almost to appear of cut, rather than wrought iron. From a pair of these scrolls, diverging at the center, a wavy tendril, with a triple beading at the base, rises to the sturdy upper horizontal member of the frame. The effect of the whole is more French than English in feeling.

FIGURE 10. PORTAL GATE, ST. PHILIP'S CHURCH

Set between the pillars at the eastern entrance to the church is a small balustrade with a pair of portal gates, probably salvaged when the older church was burned in 1835. One gate and half of the balustrade are shown.

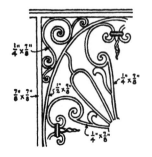

The design is essentially a vertical elongation of that of the gates and adjacent panels of the communion rail of St. Michael's.

The workmanship is less finished than that of St. Michael's, as might be expected of local execution, but is confident and vigorous. The pattern varies slightly from that of the original. There is more leaf work, the petals radiating from the center of the gate are braced with wavy, rather than straight, rods, the fillers at the corners are S, rather than C, scrolls, and the central boss is solid. Iron balls at the center points of the base of the panels separating the lower stiles help to support the railing and lend an air of greater strength.

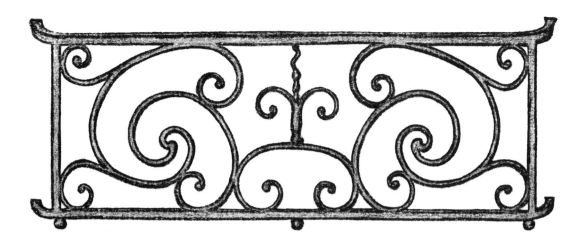

Figure 9.

Scale 18 Inches

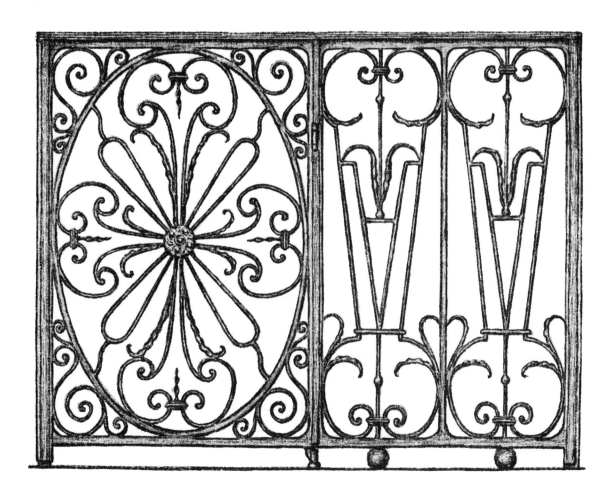

Figure 10

Scale 2 Feet

FIGURE 11. CAST BOSS, PORTAL GATE, ST. PHILIP'S CHURCH

This fine clear-cut design of leaves and scrolls was a popular one, and appears in numerous balconies, gates and grilles in the older part of the city.

FIGURE 12. CAST BOSS, GATE PANEL, ST. MICHAEL'S COMMUNION RAIL

Cast bosses were often employed to conceal the central point of juncture of radiating scrolls in circular panels. This figure, an enlargement of the detail shown in Figure 8, is unusual because of its cut-away design. The scrolls in this instance radiate from a ring, instead of a point, and with the cut-away boss achieve a delicate effect of pierced fret-work.

Figure 11.

Scale 4 Inches

Figure 12.

Scale 3 Inches

FIGURE 13. BALUSTRADE AND STAIR RAILING, BLAKE'S TENEMENTS

This fine balustrade, sweeping across the front of the old building in Court House Square known as Blake's Tenements, evokes general admiration.

Devoid of ornamentation except for the brilliantly designed central panel, it takes advantage of rises in the handrail at either end of the porch, and sudden dips where the steps descend, for decorative effect. Occasional small well-spaced posts, capped with iron terminals in the shape of dodecahedrons, help to relieve the severity of the pattern. A small footscraper is incorporated in the railing of the west landing.

The balusters, square in cross-section, protrude slightly through the flat top rail, and are finished with varying degrees of nicety.

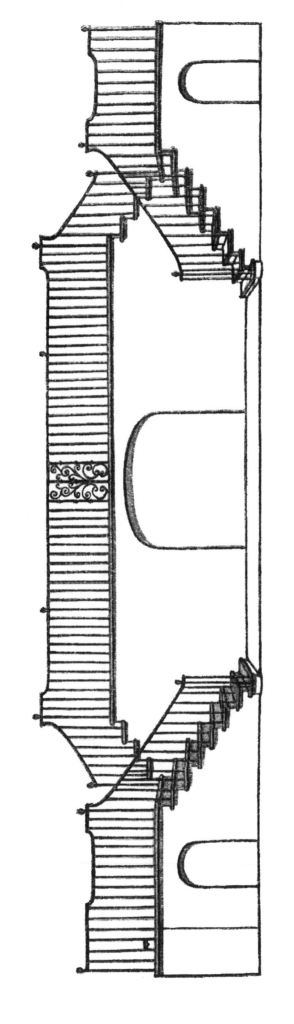

Scale 10 Feet

FIGURE 13.

Figure 14. Balustrade and Stair Railing, John Edwards House, Meeting Street

John Edwards, a well-known Charleston merchant, built his handsome wooden house during the last decade of the provincial era, and first occupied it in 1770. Identifying himself with the Revolutionary Party, he became a member of Governor John Rutledge's Privy Council, and, with other leading South Carolinians, was imprisoned by the British at St. Augustine after Charleston had fallen. Admiral Arbuthnot was quartered in the house during the occupation of the city. A number of years later, at the time of the dread Santo Domingo uprising, the family of the Count de Grasse was sheltered here.[58]

The balustrade, one of the finest in Charleston, extends across a porch narrower than that of Blake's Tenements; like it, descends to intermediate landings on either hand, then follows the fall of the steps in a double, instead of single sweep, curving outward at the bottom to face the front, instead of the center.

Like the balustrade of Blake's Tenements, it is decorated at its turning points, and at the newels, with iron dodecahedrons. The newels are almost identical in appearance with those of the former building. A moulded strap has been added to the flat handrail, probably at a later date.

The principal feature of this balustrade is its central decorative panel, repeated in the side rails of the landing (not shown in the illustration). Here appears for the first time a highly developed lyre. The design is especially fine, and, as in the case of St. Michael's communion rail, is believed to have exerted a strong influence upon subsequent wrought ironwork.

[58] *Ibid.* Pp. 196 and 199.

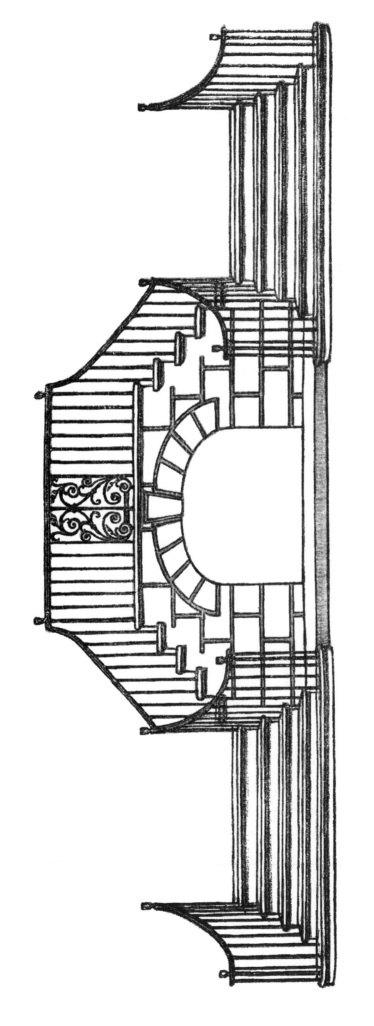

FIGURE 14.

Scale 9 Feet

FIGURE 15. BALUSTRADE PANEL, JOHN EDWARDS HOUSE

From the large S and C scrolls leaves and tendrils issue. The leaves at the center are collared to the S's, and these in turn to the central upright.

FIGURE 16. BALUSTRADE PANEL, BLAKE'S TENEMENTS

This beautiful panel, set in the midst of a plain balustrade, possesses a harmony of design of its own, a rich simplicity unusual even during the best period of Charleston wrought ironwork. Between sturdy, beaded upright bars, scrolls diverge from a similar bar at the center. From these scrolls issue long, graceful water leaves in pairs.

Here, as in the balustrade, the workmanship is irregular, but the provincial smith who created this masterpiece during the 1760's or early 1770's must, despite shortcomings in finish, have surveyed his completed work with profound satisfaction.[59]

FIGURE 17. BALUSTRADE PANEL, ORANGE STREET

The panel shown is the sole decorative element at the center of the plain iron railing of the house in Orange Street thought to have been built by Colonel Charles Pinckney about 1760. Two pairs of S scrolls, one above the other, rest upon a pair of half S's, which are supported by short, twisted vertical bars. The scrolls are collared back to back against a heavy baluster.

[59] Simons, Albert A. I. A., and Lapham, Samuel, Jr., A. I. A. Charleston, South Carolina. Plate, Blake's Tenements.

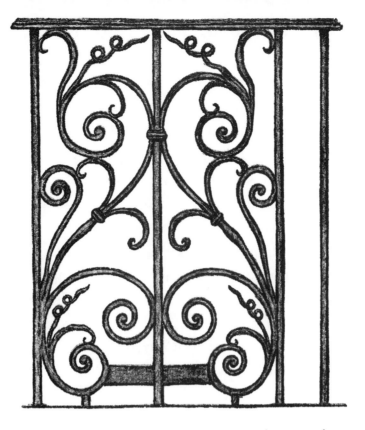

FIGURE 15.

Scale 2 Feet

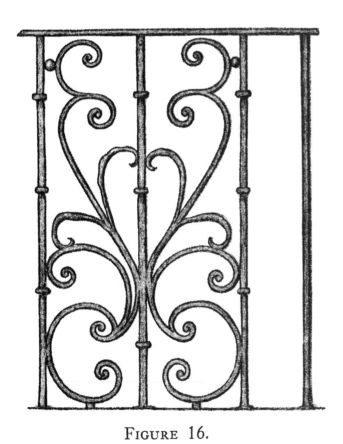

FIGURE 16.

Scale 2 Feet

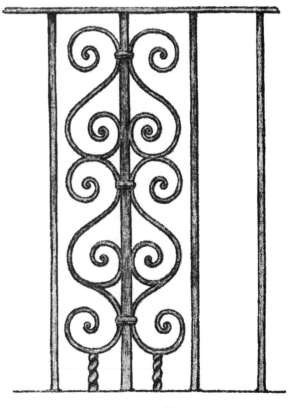

FIGURE 17.

Scale 2 Feet

FIGURE 18. GATEWAY, WESTERN CHURCHYARD, ST. PHILIP'S

This gateway and that of the Miles Brewton house are believed to be the only wrought iron ones which remain from the period antedating the American Revolution. While the date of construction of the Miles Brewton gates may readily be assumed as being contemporaneous with that of the house, that of the St. Philip's gate can be tentatively established by inference only.

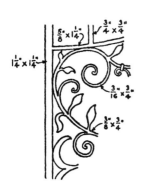

The old vestry minutes contain numerous references to cattle and horses straying into the yard, and from time to time record provisions for the building or repairing of fences or for reimbursement to owners who have had their own adjacent fences repaired. An entry of December 10, 1752, mentions the "Fences and Roof of the Church, which have been damaged and blown down by the late Hurricane." On January 8, 1770, the vestrymen agree "that the fence of the Church Yard, be repaird with Boards." In the will of George Seaman, proved July 24, 1769, the sum of two hundred pounds is bequeathed for "enclosing the Churchyard of St. Phillip's with a Brick wall or other uses," and on January 22, 1770, the minutes record an agreement "that the Pavemt on the south side of the Chh be Inlarged, that the West side of the Chh yd. where the Chh Stands be Pallasaded, and the East Side of the Opposite Chh Yd have a Brick Wall." There the matter appears to rest, as far as the vestry minutes or any other available records have disclosed. Apparently the brick wall, a low one, was built, and the plain iron fence which surmounts it, as well as the superb gate itself, were so far taken for granted as to be made at the same time and put up without the clerk's taking the trouble to mention them.

The gates, suspended from high, stuccoed brick pillars capped with stone balls, contain three principal panels, the upper and lower of plain vertical bars, square in cross section and pointed at the top, where they project through the upper stile. An arc separates the upper panel from the elaborately foliated one at the center, where a superb arrangement of broken and S scrolls, collared to one another and decorated from end to end with small twisted leaves and occasional finely worked husks with indented edges, presents a pattern of unrivalled artistry.

56

Figure 18.

FIGURE 19. CENTRAL PANEL OF BALCONY, FORMERLY AT 87 EAST BAY

This balcony has already been referred to as exemplifying a possible transition period in design, in that the central panel displays certain characteristics 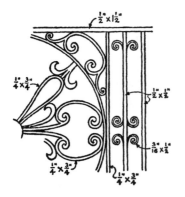 of the older style, notably the use of broken curves and well-overlaid husks, and is a modification of the pattern of the gates of the communion rail at St. Michael's. The new style is foreshadowed in the balustrades with their top and bottom scrolls, although these, unlike the ones so much employed in the balconies of the Adam period, are not tangent to one another at the center. Another point of dissimilarity is that both top and bottom scrolls curve in the same, instead of opposite directions, as in the later work.

FIGURE 20. BALCONY WITH SUPPORT BRACKET, CORNER OF BROAD AND CHURCH STREETS

One of the finest balconies in the city, combining imaginative grace in the lotus-flower design and the scrolls of the balusters, with sturdy solidity in the twisted intermediate uprights capped with solid cast terminals.

This balcony, clearly a transition example, is on the Broad Street front of an old building with fine simple interior panelling. In the remodeling of the building, the balcony was moved from the second floor, opposite the central window of the drawing room, to the third.

The support consists of a plain single bracket.

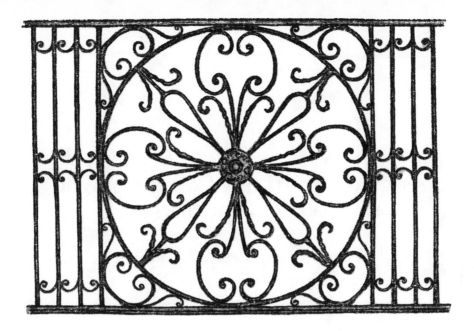

FIGURE 19.

Scale 3 Feet

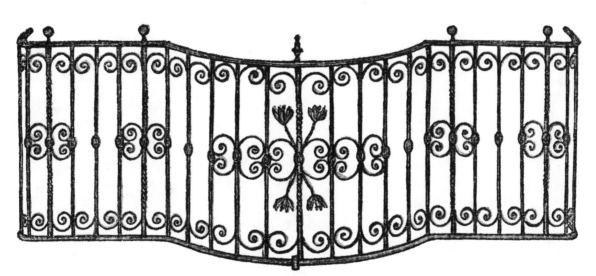

FIGURE 20.

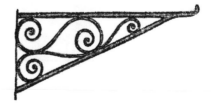

Scale 4 Feet

FIGURE 21. SECTION OF BALCONY WITH SUPPORT BRACKET, TRADD STREET NEAR MEETING

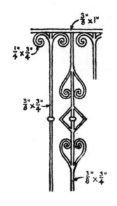

A large balcony, removed a number of years ago from a building in State Street.

It appears to be of a transition design, dating probably from a short time before the American Revolution. The balusters, scrolled at either end, are beaded at the center so as to resemble somewhat the Spanish spindle type of decoration of the 18th century.

The top rail is a single member, and is moulded. The balcony is supported by a large, plain, central bracket.

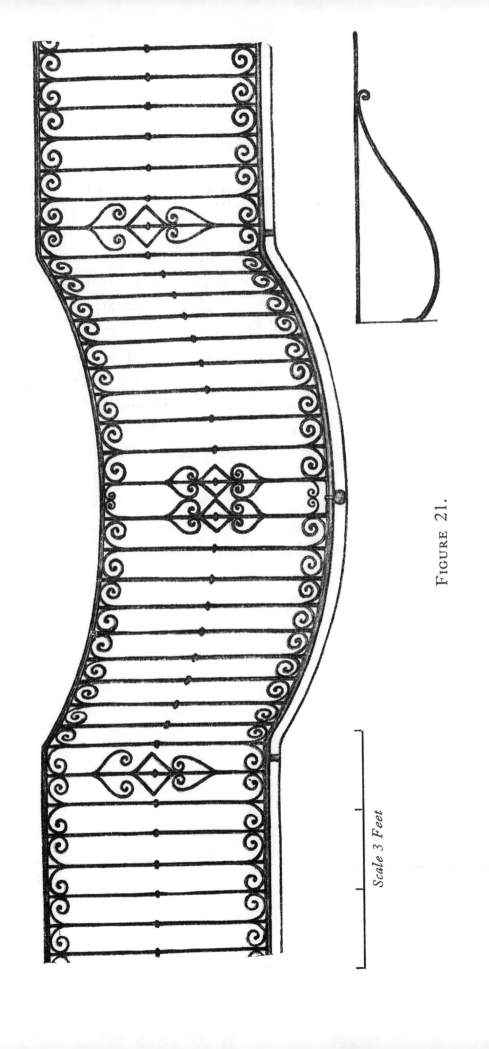

FIGURE 21.

Scale 3 Feet

FIGURE 22. BALCONY WITH SUPPORT BRACKET, BROAD STREET NEAR KING

This delicate and harmoniously designed balcony is of the style which appears to have been popular in the earlier phase of the Adam period, before the appearance of those with more sturdy balusters decorated with a continuous series of scrolls at top, bottom and center.

In this example, as in that at the corner of Broad and Church Streets (Figure 20), there are scrolls at top and bottom only, with central cast lead rosettes. The regularity of this arrangement is relieved by the inclusion of balusters scrolled at the center as well. Curiously, in this balcony, the triple scrolled member is off center, there being nine of the plain type to one side, and ten to the other.

The house contains Chippendale woodwork, and Adam exterior features, which tend to indicate that the balcony was added during a period subsequent to the date of construction of the building itself.

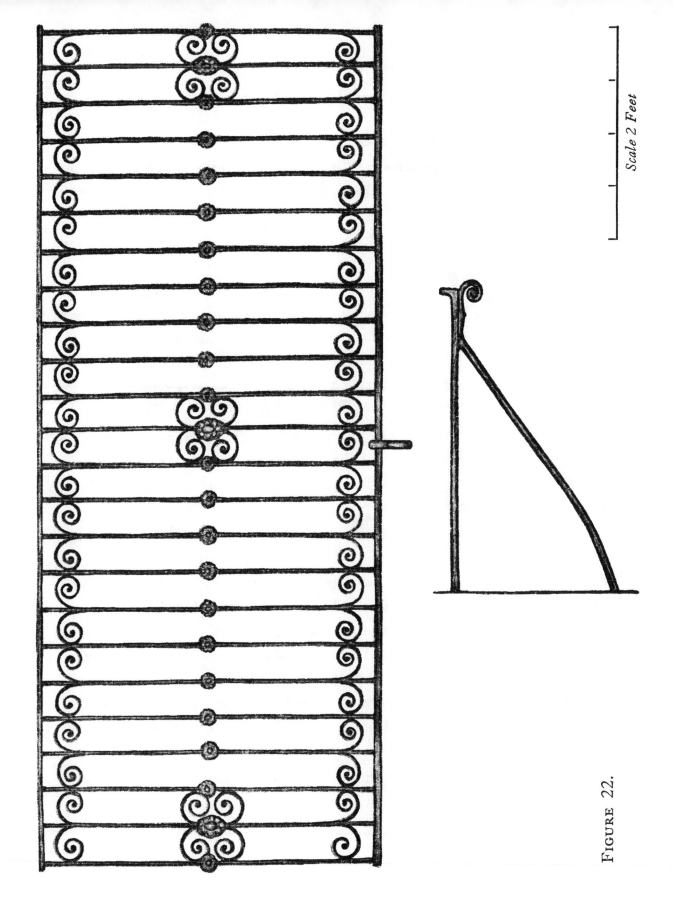

Scale 2 Feet

Figure 22.

FIGURE 23. BALUSTRADE AND STAIR RAILING, WILLIAM GIBBES HOUSE, SOUTH BATTERY

An interesting example of a combination of designs.

The balustrade sweeps across the stone porch along the steps to the landing, thence at right angles in a double descent to the street in the same manner as does that of the John Edwards house. The railing, with its balusters, the decorative panels on the right and left, and the newel post, all of sturdy material and of early design, obviously belong to the original pre-Revolutionary structure. The lantern standards, central decorative panel and brass urns appear to have been added when the house was remodelled; this remodelling is thought to have been effected about 1785.

The design of the side panels, a series of S scrolls interrupted by a pair of horizontal knobs, and placed back to back against a central upright, is similar to that of the balcony rail shown in Figure 3. The top rail is moulded, and consists of a single member.

The central panel, of later work, is almost identical with that of the stair rail of the now demolished Gabriel Manigault house at the corner of Meeting and George Streets, and of two balconies, one in Church Street and the other in the Charleston Museum, and is a modernized version of those of St. Michael's Communion rail and the balcony shown in Figure 19. From a central cast boss radiate light spokes, the horizontal and vertical ones each decorated with three pairs of conventionalized leaves or tendrils, the oblique ones plain. These spokes all terminate on the circumference of a small circle concentric with a larger outer circle and separated therefrom by eight rings. In each corner of the panel is a pair of diverging scrolls.

The lantern standards, with trimmings of slender scrolls and flames, support plain scrolls holding circular lantern rings.

Scale 12 Feet

Figure 23.

FIGURE 24. BALUSTRADE, WILLIAM GIBBES HOUSE

This enlarged drawing of the balustrade shown in Figure 23 is included for the purpose of showing the design in greater detail.

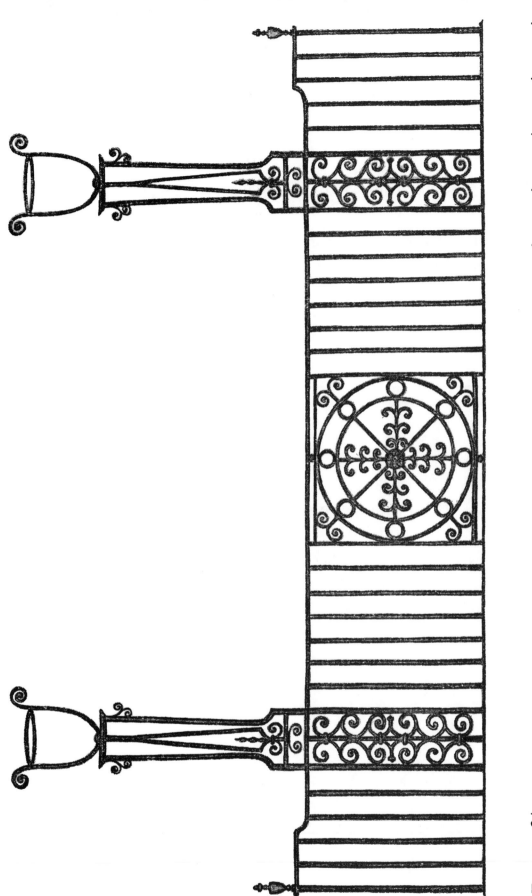

FIGURE 24.

FIGURE 25. NEWEL POST, BLAKE'S TENEMENTS

The handrail curves to a chamfered newel post, capped, like the intermediate posts of the balustrade, with an iron dodecahedron.

FIGURE 26. NEWEL POST, WILLIAM GIBBES HOUSE

This newel, twisted in a rather crude and irregular manner, is decorated with a turned brass urn of the Adam period, which probably replaces an earlier terminal similar to that shown in Figure 25.

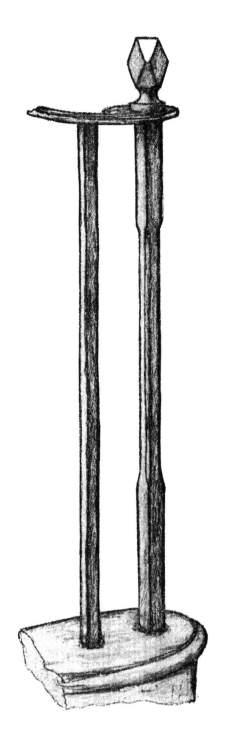

FIGURE 25.

Scale 15 Inches

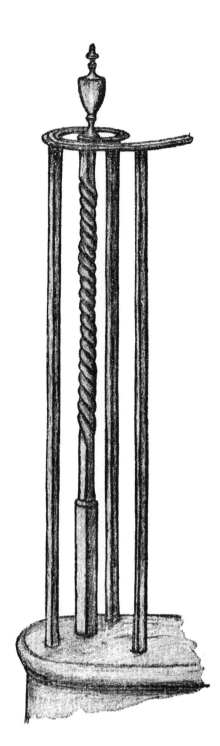

FIGURE 26.

Scale 15 Inches

FIGURE 27. SHELF BRACKET FROM FAIRFIELD

There are two pairs of these brackets, both in the Miles Brewton house. That pair of which one is shown in the illustration was brought recently from Fairfield, the plantation of William Alston. The plantation house at Clifton is thought to have been the original setting of both. President Washington, who spent a night there in May, 1791, while on his Southern tour, describes the house as "large, new and elegantly furnished." These brackets, together with their marble shelves, would have been in keeping with new furniture of the period.

They are highly finished both in design and in workmanship, and were probably brought from England. A combination of cast and wrought work includes a horizontal panel filled with rings tangent to one another, and a vertical panel containing three elongated ovals, above which rises a Greek honeysuckle with long stem and opening leaves. The space from the horizontal to the vertical extremities of the brackets is filled with a broken scroll, with leaves and rosettes and a flame at the base. Intertwined are bay leaves and buds.

The rings, the Greek honeysuckle and the rosettes are of cast brass. The rest is wrought iron.

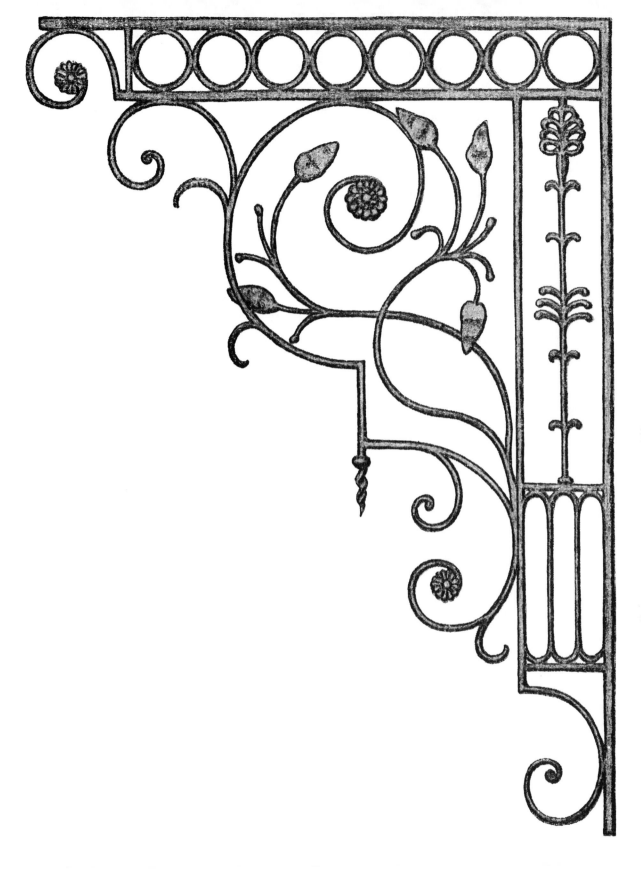

FIGURE 27.

Scale 8 Inches

FIGURE 28. WINDOW GRILLE, 54 BROAD STREET

The house at 54 Broad Street is said to have been built by the brothers Peter and John Horlbeck with materials left over from the building of the Exchange, which was completed in 1772. The interior decoration is of the Adam style, as are the two fine grilles of which one is shown. These grilles are inconspicuously set in window casings in the east wall of the building.[60]

Although of sturdy construction, they are unusually delicate and beautiful in design. Vertical bars, beaded near their extremities, issue, top and bottom, from half-opened buds along the horizontal stiles. At a short distance from the beaded portions, scrolls in pairs diverge to the right and left, and are collared to short alternate uprights beaded like the longer ones. These short bars, or uprights, project through the buds and end in blunted points. The long bars are decorated at the centers with six petalled flowers displayed fully opened.

The bars, stiles and scrolls are wrought; the buds and flowers cast. Supporting the lower stile are thick oval castings in vertical line with the shorter uprights.

FIGURE 29. WINDOW GRILLE, CHARLESTON MUSEUM

This grille is thought to have been removed from the old Bank of the State of South Carolina, built about 1795, and formerly standing on the northwest corner of Broad and State Streets. It is of a particularly pleasing and harmonious pattern.

[60] *Ibid.* P. 19 and Plate, Exchange and Custom House.

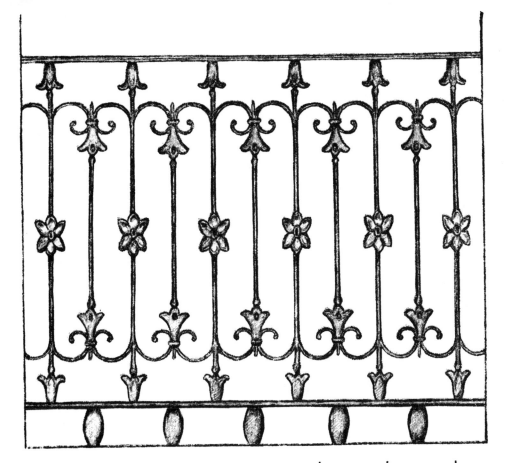

FIGURE 28.

Scale 18 Inches

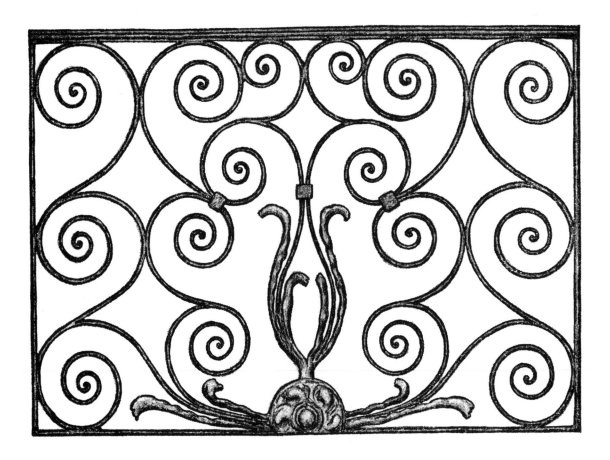

FIGURE 29.

Scale 18 Inches

FIGURE 30. PASSAGEWAY GRILLE, "CABBAGE ROW," CHURCH STREET

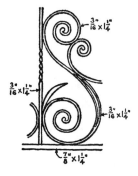

There is no upper frame to this grille, which fits into the arched entrance to the passageway of a building known as "Cabbage Row," the prototype of the "Catfish Row" of Dubose Heyward's novel *Porgy*.

The design is excellent; the workmanship crude. S scrolls, to which triple outer scrolls are attached, and having a pair of husks at the base, are braced back to back against a twisted central upright. Irregularities at the point of juncture of the triple scrolls indicate that additional pairs of husks once existed at these points also, and have rusted away.

FIGURE 31. LUNETTE, ELLIOTT STREET

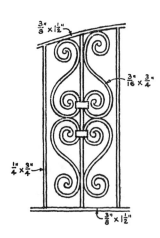

A driveway lunette of plain bars, square in cross section, relieved by three panels of paired dolphin scrolls placed end to end, and collared to the upright.

FIGURE 32. LUNETTE, ELLIOTT STREET

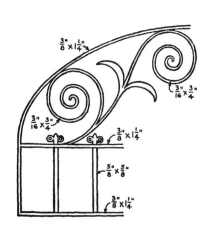

A passageway lunette of somewhat later date than that shown above. Broad strokes are employed in an unusual design, less restrained, yet more imaginative, than that of Figure 31.

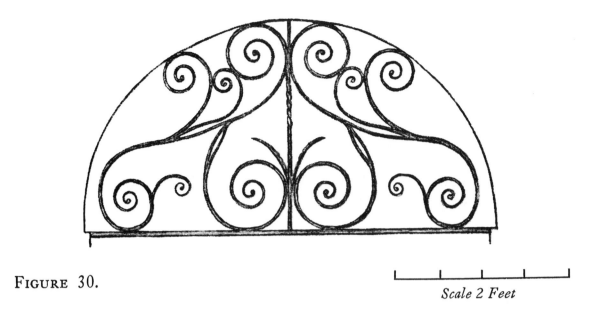

FIGURE 30.

Scale 2 Feet

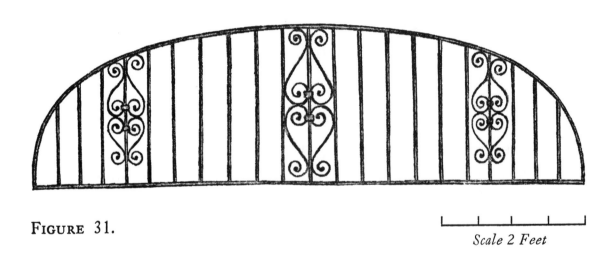

FIGURE 31.

Scale 2 Feet

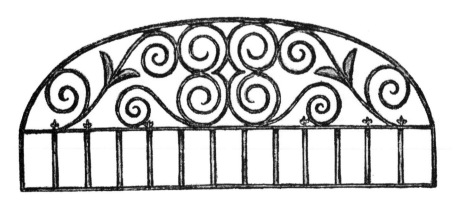

FIGURE 32.

Scale 2 Feet

FIGURE 33. BALCONY SUPPORT BRACKET, CHURCH STREET, NEAR CHALMERS

One of a pair supporting a small curved balcony. The simple S scroll, with which is combined a smaller and similar scroll at the center, is unusually effective.

FIGURE 34. BALCONY SUPPORT BRACKET, LOWER TRADD STREET

One of an irregular pair supporting a small curved balcony. There is no decoration to the functional members, other than a single scroll at the extremity of the base.

FIGURE 35. BALCONY SUPPORT BRACKET, CORNER OF ELIZABETH AND HENRIETTA STREETS

This bracket is one of a pair supporting a balcony owned by the Society for the Preservation of Old Dwellings.

It is set cornerwise to the street, and is the only one so placed in the city. The small wooden building to which it is attached is thought to have been built as a tavern.

FIGURE 36. BALCONY SUPPORT BRACKET, TRADD STREET, NEAR CHURCH

A single bracket, placed at the center of a long balcony. C and S scrolls, pleasingly varied, afford a base for leaves and tendrils, of which one or more may have rusted away.

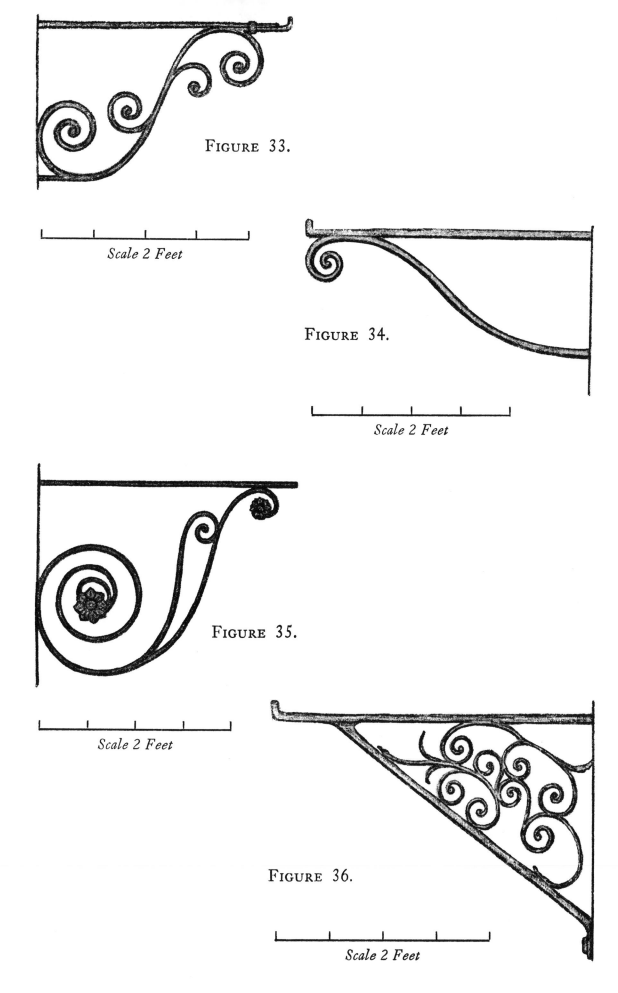

FIGURE 33.

Scale 2 Feet

FIGURE 34.

Scale 2 Feet

FIGURE 35.

Scale 2 Feet

FIGURE 36.

Scale 2 Feet

FIGURE 37. SECTION OF BALCONY WITH SUPPORT BRACKETS,
NATHANIEL RUSSELL HOUSE, MEETING STREET

Nathaniel Russell, who built this house about 1811, was a wealthy New England merchant who settled in Charleston and was long a prominent figure in the life of the city.[61]

The balcony extends across the front and sides of the building, and includes in the front central bay the wrought initials of the builder. The balusters, scrolled at the centers and extremities, are characteristic of balconies of the period.

There are three styles of support brackets; long and severely plain for the curved bays, and scrolled for the straight lengths.

[61] Smith, Alice R. Huger and D. E. Huger. The Dwelling Houses of Charleston, South Carolina. Pp. 142-155.

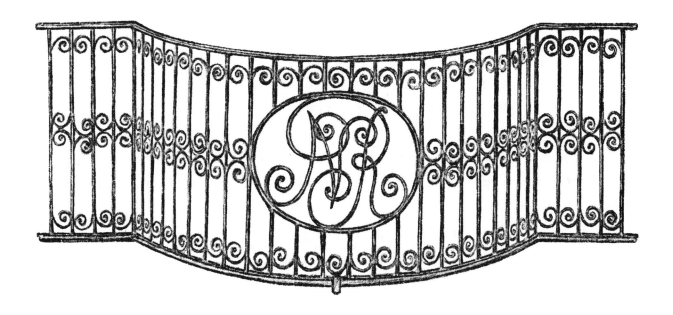

FIGURE 37.

Scale 3 Feet

FIGURE 38. BALCONY WITH SUPPORT BRACKETS, KING
STREET, NEAR LADSON

This balcony is one of a pair on opposite houses in lower King Street. They were removed several years ago from a building in Broad Street which was being remodelled.

The balusters are similar to those in Figure 37. The central panel contains a scroll and lyre motif, collared near the top and bottom as in the older work.

There are four scrolled support brackets.

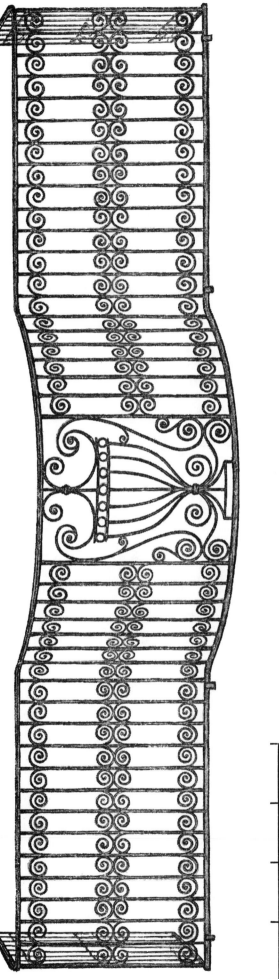
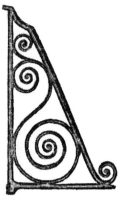

Scale 4 Feet

Figure 38.

FIGURE 39. FANLIGHT, SOUTH CAROLINA SOCIETY HALL

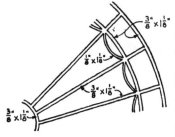

Wrought iron Adam fanlights are often of delicate design, but few surpass this one in purity and simplicity. The three concentric semicircles, with rays from the inner to the outer, are unadorned except for the series of loops dropping from the intersection of these rays with the second arc.

The grille covers the basement window, which opens on the lower front landing.

FIGURE 40. BALUSTRADE PANEL UNITS, SOUTH CAROLINA SOCIETY HALL.

The columns of the South Carolina Society Hall, together with the trees of Meeting Street, the high brick wall and white spire of St. Michael's, constitute a scene which is world famous.

The railings of the steps and landings, contemporary in period with the building (1804), are cut away at the lower level to permit the attachment of the older lantern standards shown in Figure 4.

The pattern of high scrolled S's and husks is repeated the length of the railing, and is one of the most attractive designs in the city. An overlaid strip, curved in cross section, is attached to the handrail.

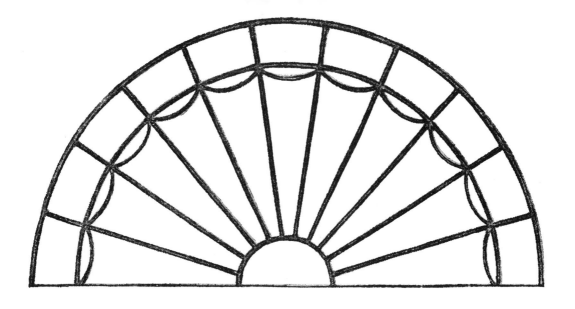

FIGURE 39.

Scale 3 Feet

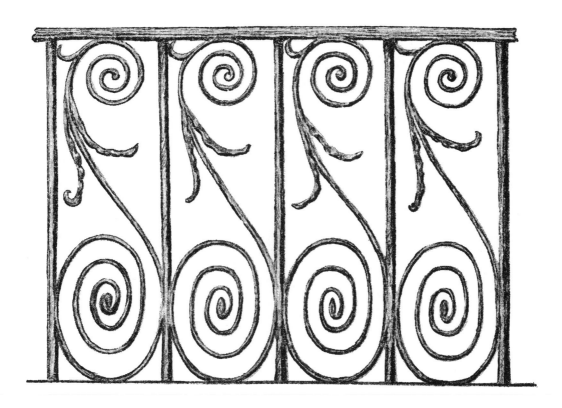

FIGURE 40.

Scale 2 Feet

FIGURE 41. BASEMENT GRILLE, CITY HALL

The bull's-eye grilles of Manigault's City Hall, originally the United States Bank, are placed at intervals along the front and sides of the building and protect the long, tunnel-like basement windows.

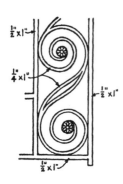

From a central cast boss, petals radiate to the inner circumference of two concentric circles. Between this and the outer circumference is a band filled with an endless circle of dolphin scrolls. The design is pleasing, but in its regularity and in that of the workmanship, there is a foreshadowing of the mechanical exactness of a later period.

FIGURE 42. BASEMENT GRILLE, CITY HALL

This design appears in the grilles to the two back basement windows of the City Hall, and is thought to be one of the earliest examples in the city of the employment of the anthemion, or Greek honeysuckle, in wrought iron.

The treatment is free and open. The conventional flower elements depart from the accepted form in an individual interpretation by the architect.

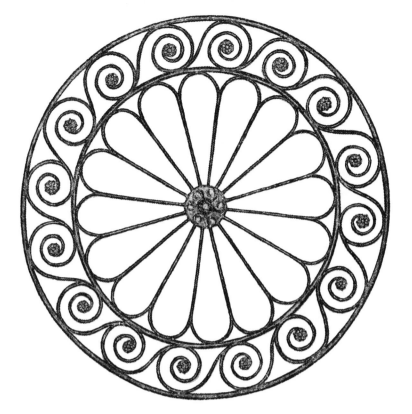

FIGURE 41.

Scale 30 Inches

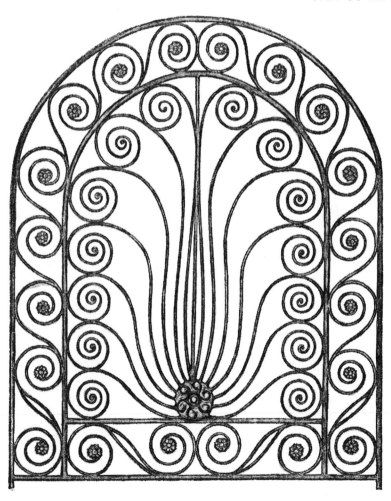

FIGURE 42.

Scale 30 Inches

FIGURE 43. PORCH BALUSTRADE, WILLIAM BLACKLOCK HOUSE, BULL STREET

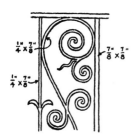

In the balustrade of this house, which bears the date 1800 on the stone lintel of the front basement door, there is a definite lyre motif, reminiscent of that in the John Edwards railing, but with a new and more geometrical interpretation. From this time on, the lyre, in many forms, is of frequent recurrence.

Here, as in the grilles of the City Hall, while the design is agreeable, a certain coarseness, absent from the earlier work, is apparent. The scrolls and flame are entirely in the flat. A survival of the older work is manifested in the use of a single moulded member as handrail, and of iron, instead of brass, terminal balls. It is of interest to note that the scrolls of the side panels are reversed in direction with respect to each other.

FIGURE 44. PANELS, PORCH BALUSTRADE, RADCLIFFE-KING HOUSE, CORNER OF GEORGE AND MEETING STREETS

The Radcliffe-King house was long a celebrated landmark in the social, literary and educational life of Charleston.

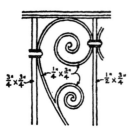

Built by Thomas Radcliffe in 1806, it was sold by his widow to Judge Mitchell King in 1824. Here, during the second and third quarters of the 19th century, were held the meetings of the literary club of which so many celebrated Charlestonians were members. Here also Mrs. King gave her famous balls during Race Week.[62]

Subsequent to the ownership of the King family, the house was used by the Charleston High School. In recent years it was demolished to make room for the present Student Activities Building of the College of Charleston.

The center panels of the porch balustrade, of nearly the same date as that of the William Blacklock house, are almost an exact duplicate, inverted, of this panel. The principal features differentiating it from the slightly earlier piece are the slenderness of the scrolls, the absence of wavy points, or flames, and the use of collars. The handrail is a single moulded member, as in the Blacklock railing.

62 *Ibid.* Pp. 140-142.

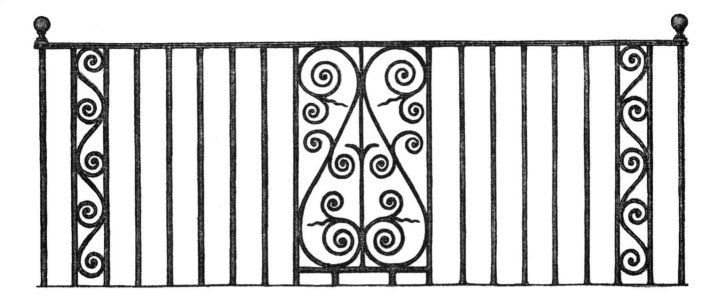

FIGURE 43.

Scale 3 Feet

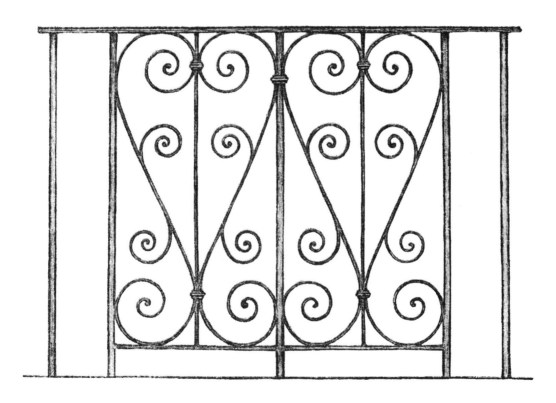

FIGURE 44.

Scale 2 Feet

FIGURE 45. GATEWAY, RADCLIFFE-KING HOUSE

This gateway consists of a large pair of central gates set between two high brick piers capped with marble facings. On either hand is a lower and narrower gate, which carries out the design of the central pair. Beyond a second pair of brick piers, the iron fence stretches to the right and left. The continuation of the fence on Meeting Street in the same design as that of the George Street front is modern, and replaces a brick wall removed to permit the passage of more light and air for the present building.

The fence is of heavy bars, square in cross-section and set edgewise to the street, and capped with alternate spear and javelin heads, the barbs of the spearheads being scrolled. Spaced along its length are urn-shaped terminals of turned brass.

The bars of the gates, also square in cross-section, are set flat edge to the front, with an overthrow continuing this pattern, and capped with spear and javelin heads similar to those of the fence.

There are two decorative panels, one bounded on its lower side by a curve somewhat more shallow than that of the gate to St. Philip's western churchyard, and the other an oblong one at the lock rail.

The design of the whole is rather "tight" and squeezed in, and of provincial quality. In spite of the presence on the fence of brass urns of the Adam period, it seems not altogether unlikely that the construction of both gates and fence antedates that of the house.

The stucco facing of the brick posts is relatively modern. Through its use there is a loss in the pleasing contrast in color between the grey-red brickwork and the white marble top panels of the original design.

Scale 4 Feet

FIGURE 45.

FIGURE 46. GATEWAY, FIRST PRESBYTERIAN CHURCH, MEETING STREET

The solid dignity of the gates and fence of the First Presbyterian Church is in keeping with the simple lines of the large classical porch of the building.

The influence of the old designs in wrought iron is apparent in the moulded pickets and in the terminals of the pilasters, but there is no employment of overlaid or applied work, nor of delicate scrolls of the kind which had been popular up to this period. On the other hand, while the design of the pilasters distinctly foreshadows that of the work of the 1820's and subsequent years of the 19th century, the overelaboration characteristic of much of this later work is pleasingly absent.

The bars of the gate are set edgewise, rather than parallel to the street, an unusual arrangement.

It is interesting to note that the fence of St. Paul's Church, on Coming Street, built at about the same time, is of a nearly identical pattern.[63]

[63] Simons, Albert, A. I. A., and Lapham, Samuel, Jr., A. I. A. Charleston, South Carolina. Plate, St. Paul's Church.

90

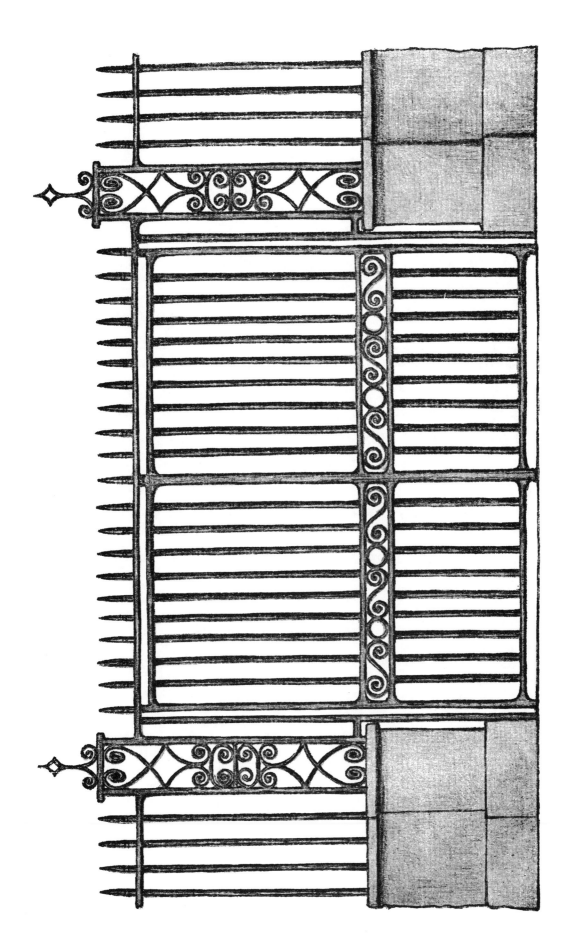

Figure 46.

Scale 5 Feet

FIGURE 47. GATEWAY, ST. ANDREW'S SOCIETY HALL, BROAD STREET

The St. Andrew's Society hall was burned in the fire of 1861, but the fence, with two of its three gates, is still intact.

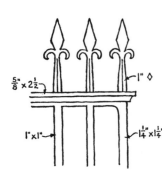

The design is a simple one of spear heads and plain bars, with iron loops and arrows at the base. The bars of the gate and the first adjacent ones of the fence on either side are set parallel to the street, as is the case with most of the gates with bars square in cross-section. The remaining bars of the fence are set edgewise to the street.

This is the only example of old gates in which dog bars were used. In later gates there is frequent use of a lattice of flat diagonal strips, decorated at the intersections with cast rosettes.

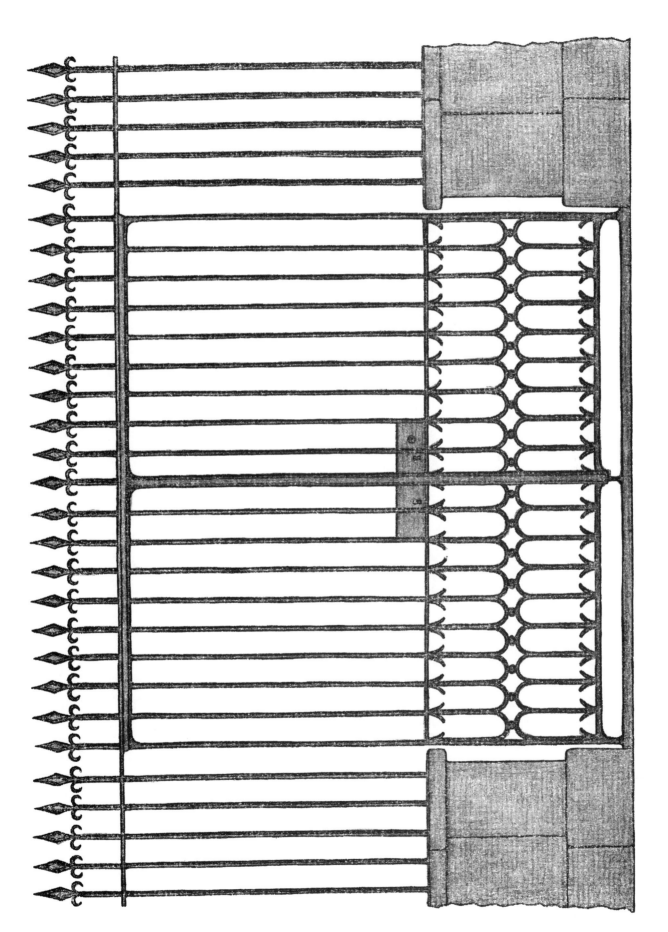

FIGURE 47.

Scale 3 Feet

FIGURE 48. GATE AND FENCE BRACES, FIRST PRESBYTERIAN
CHURCH

The braces to the gate are set in the ground level; those to the fence in the
coping of the wall.

FIGURE 49. GATE AND FENCE BRACES, ST. ANDREW'S SOCIETY
HALL

The gate braces are of single, rather than double scrolls, as in Figure 48.

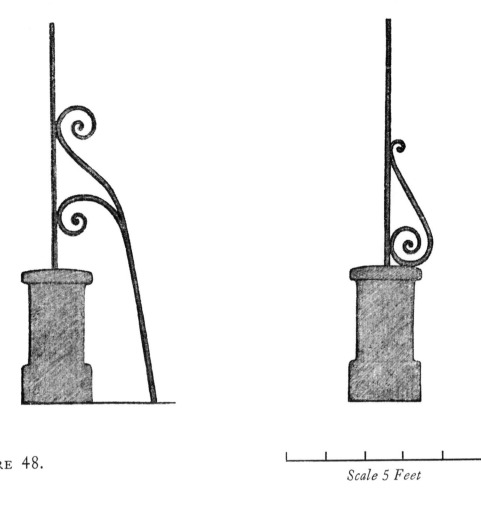

FIGURE 48.

Scale 5 Feet

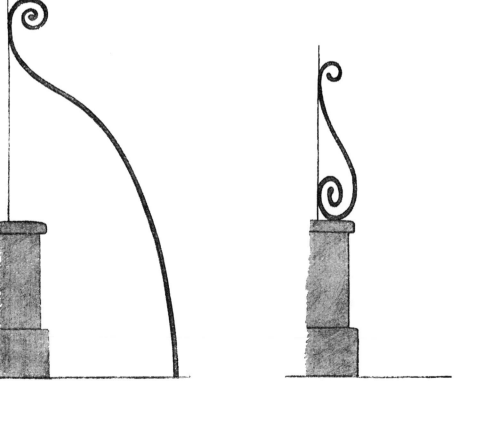

FIGURE 49.

Scale 4 Feet

FIGURE 50. GATEWAY, FIRST BAPTIST CHURCH, CHURCH STREET

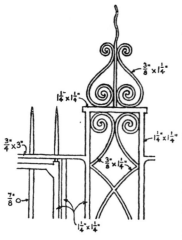

Robert Mills designed the First Baptist Church (erected 1822) and possibly the ironwork of the gates and fence as well.[64]

The pattern is simple and vigorous, of alternate curves and lozenges. The bars are round in cross-section. The terminals of the pilasters have developed into the pattern which became popular about the period in which the church was built, and remained in vogue for many years thereafter. The braces closely resemble those of the First Presbyterian Church.

[64] *Ibid.* P. 174.

96

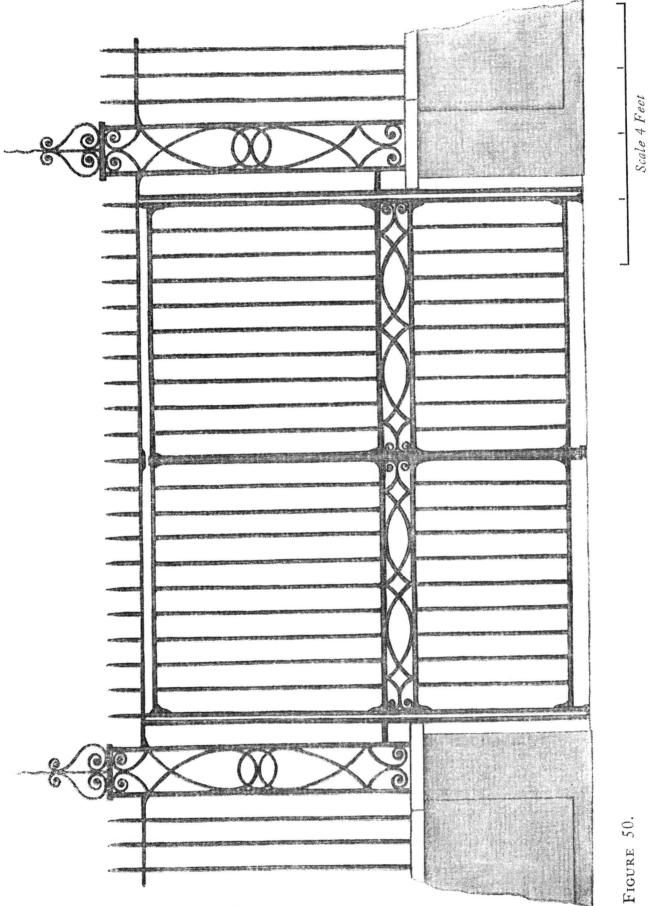

Scale 4 Feet

Figure 50.

Figure 51. GATEWAY, WILLIAM WASHINGTON HOUSE, SOUTH BATTERY

This house was built by Thomas Savage in 1768, and was subsequently purchased by Lieutenant Colonel William Washington, the hero of the battle of

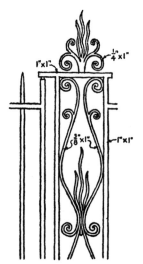

the Cowpens. In 1830, or later, Washington's daughter, Mrs. James Hasell Ancrum, enlarged the property by purchasing from the city a strip of land on the Church Street and South Battery frontages.[65]

The date of the gates and fence is thus open to some speculation. While they appear to be of early and rather provincial design and workmanship, they may in fact have been forged in the 1830's and for that reason have not been discussed until this time.

The round palings project through a flat single member, which is given an appearance of greater width by a strip fastened along its face. The lock rail panel contains graceful S scrolls placed end to end. The long slender scrolls in the fillers and terminals of the pilasters, together with the wavy points and husks at the tops and at the points of junction of the pairs of scrolls, give a curiously marine appearance to the whole. The effect of the pattern, against a background of green lawn, is particularly pleasing.

[65] Smith, Alice R. Huger and D. E. Huger. The Dwelling Houses of Charleston, South Carolina. Pp. 187-189.

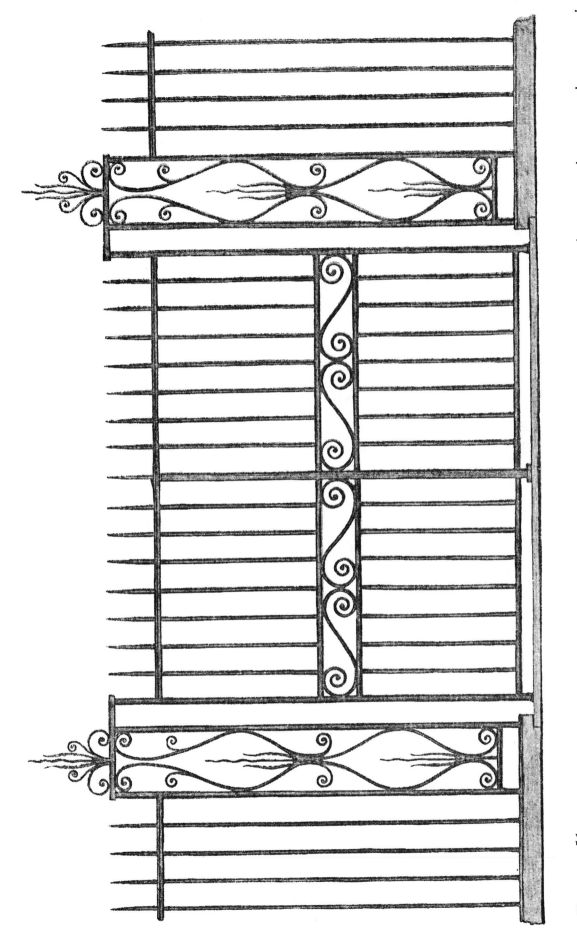

Figure 51.

FIGURE 52. SIGN SUPPORT, QUEEN STREET, CORNER OF PHILADELPHIA ALLEY

This sign support, a fine example of the popular spear design, has recently been removed from its position on an old building in Queen Street. It is thought to date from the last quarter of the 18th century.

The twisted braces and auxiliary supporting rod were fastened into the masonry of the building. The barbs of the spear are delicately scrolled. An independent decorative scroll rises from the shaft of the spear near the braces.

FIGURE 53. LOCKSMITH'S SIGN, MEETING STREET

From between a pair of converging scrolls a hand grasps a large gilded key with a scepter-like shank, and at the top, a lyre decorated with oak leaves and acorns.

Nearly all of the early tradesmen's signs have disappeared from Charleston, as elsewhere. This particular example is known to have occupied its present position for three generations of locksmiths.

FIGURE 54. SIGN SUPPORT, EAST BAY, NEAR BROAD

A graceful departure from the conventional spear design, thought to be of early 19th century workmanship.

100

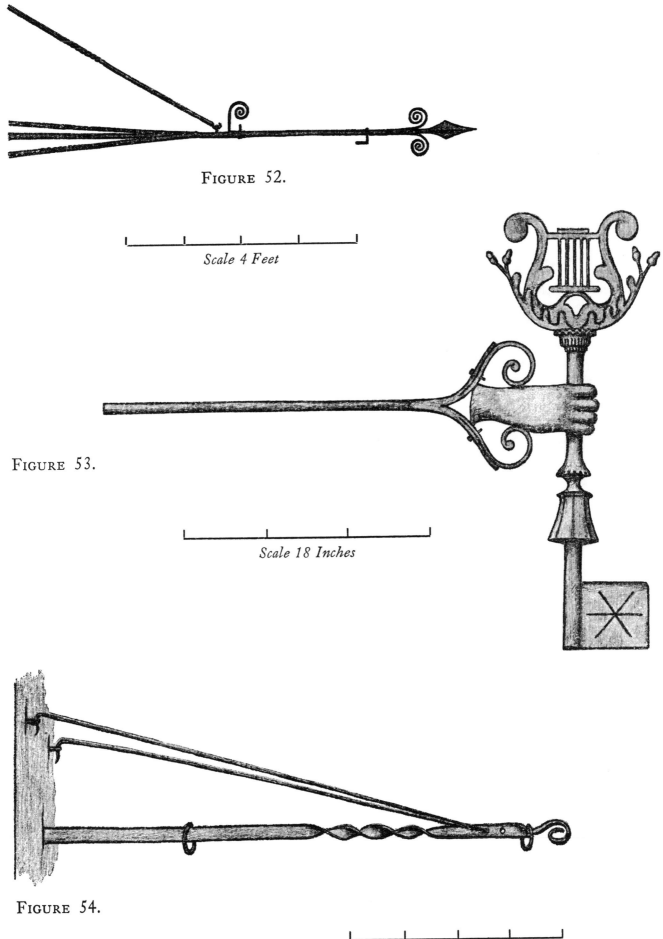

FIGURE 52.

Scale 4 Feet

FIGURE 53.

Scale 18 Inches

FIGURE 54.

Scale 2 Feet

FOOTSCRAPERS

Charleston footscrapers conform in design to those found in many towns and cities of the Atlantic seaboard.

That shown in side view in Figure 55 is one of the earlier types, and is from the Mansion House, which formerly stood immediately behind St. Michael's Church, in Broad Street. It is thought to date from the third quarter of the 18th century. The blade is missing.

Figure 56 shows one of a pair at the entrance to the John Stuart house, Tradd Street, dating from about 1772.[66]

Figure 57. An early 19th century example in the Charleston Museum.

Figure 58. On a house on East Battery, at the corner of Water Street. A late example of an early design.

[66] Simons, Albert, A. I. A., and Lapham, Samuel, Jr., A. I. A. Charleston, South Carolina. Plate, Colonel John Stuart's House.

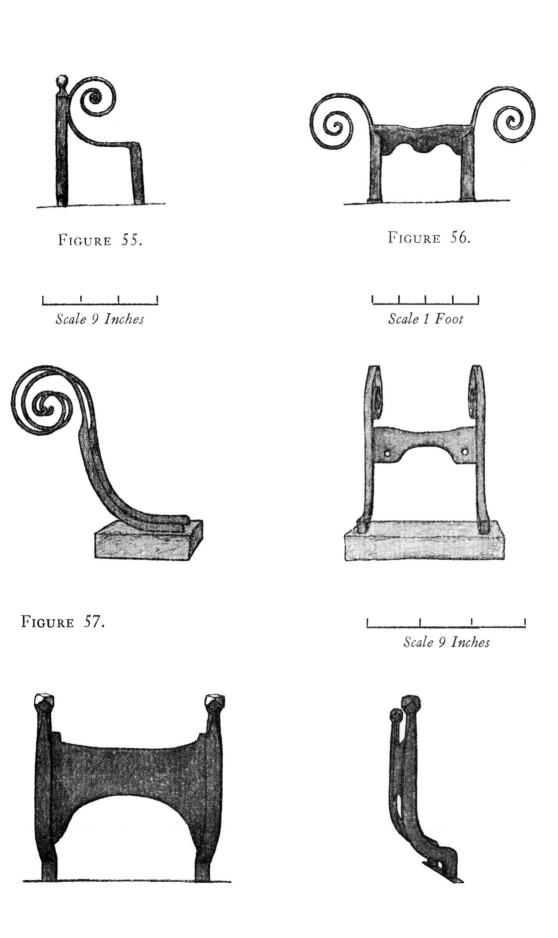

FIGURE 55.

Scale 9 Inches

FIGURE 56.

Scale 1 Foot

FIGURE 57.

Scale 9 Inches

FIGURE 58.

Scale 9 Inches

SHUTTER GUARDS

Shutter holders, or guards, were important adjuncts when the shutters which screened the interiors of the houses from the light and heat of the bright southern sun were thrown open.

The earliest examples were plain and simple, often flat cut or hammered S's. By the third quarter of the 18th century, a flat guard drawn at one end into a scrolled rat tail had become popular. A few years later, during the Adam period, wrought S's, with broken curves at the center, were in general favor. These are probably the most pleasing to the eye of the many types used.

The figures show examples of both kinds of shank, that for a wooden, and that for a brick building. Figure 63 shows a rat-tailed specimen from which the shank has been removed.

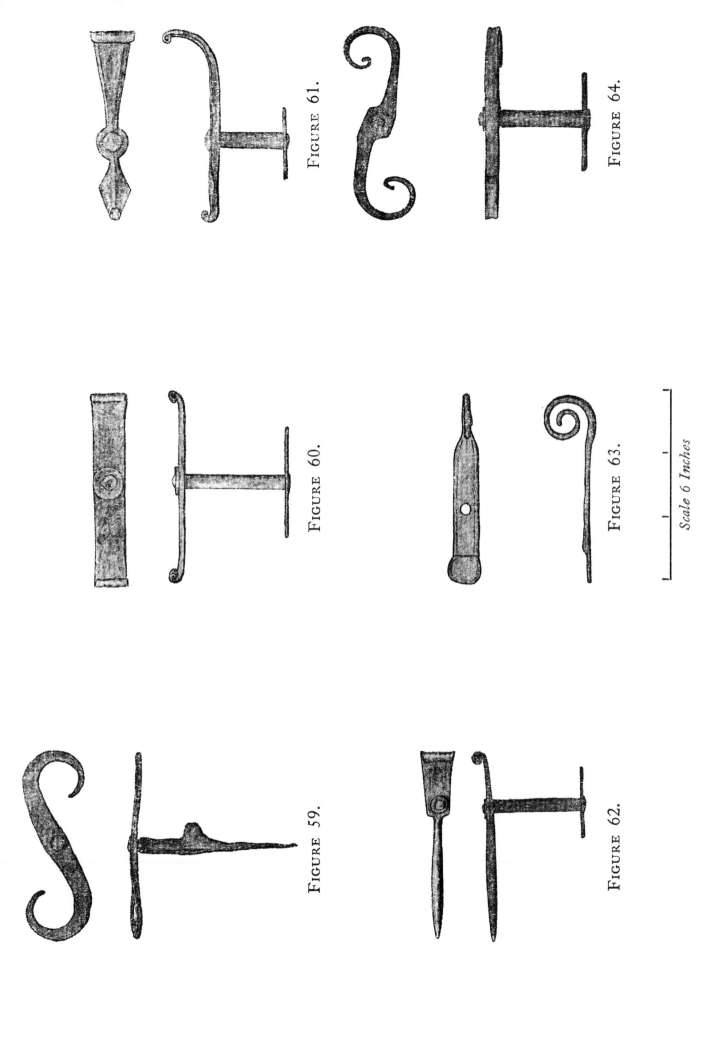

FIGURE 61.

FIGURE 64.

FIGURE 60.

FIGURE 63.

Scale 6 Inches

FIGURE 59.

FIGURE 62.

INDEX

BIBLIOGRAPHY

MANUSCRIPT SOURCES

Felder, Mrs. Alice Rutledge. Letter in the possession of the author.

Hibernian Society, Charleston. Minutes.

Holmes, Mrs. A. J. C. Letter in the possession of the author.

Manigault Family Record, Charleston Museum.

Pringle, Robert. Letter book in the possession of the Misses Mary Brewton Frost and Susan Pringle Frost, Charleston.

St. John's Lutheran Church, Charleston. Minutes of the vestry and wardens.

St. Michael's Church, Charleston. Minutes of the vestry and wardens.

St. Philip's Church, Charleston. Minutes of the vestry and wardens.

PRINTED SOURCES

Adam, Robert, and Adam, James. The Works in Architecture of. Facsimile reproductions of plates, John Tiranti and Company, London.

Charleston, South Carolina. Year Books of the City of. William A. Courtenay, editor. Charleston, 1880 *et seq*.

Chatterton, Fredrick, F. R. I. B. A. English Architecture at a Glance. G. P. Putnam's Sons, New York and London, 1925.

Cromwell, O. Directory of Charleston, 1829.

Frary, I. T. Thomas Jefferson Architect and Builder. Garrett and Massie, Richmond, 1931.

Fraser, Charles. Reminiscences of Charleston. John Russell, Charleston, 1854.

Garden, Alexander. Anecdotes of the Revolutionary war in America. Charleston, 1822.

Gardner, J. Starkie. English Ironwork of the 17th and 18th centuries. B. T. Batsford, London. [1911.]

Gibbes, Robert Wilson. Documentary History of the American Revolution. Appleton, 1853-1857.

Godfrey, Walter H., F. S. A., F. R. I. B. A. The Story of Architecture in England. Harper and Brothers, New York and London, 1928.

Goodwin-Smith, R. English Domestic Metal Work. F. Lewis, Leigh-on-Sea, Essex, 1937.

Henderson, Archibald. Washington's Southern Tour. Houghton Mifflin Company, Boston and New York, 1923.

Jackson, Sir Thomas Graham, Bart., R. A. Architecture. Macmillan and Company, London, 1925.

Johnson, Joseph. Traditions and Reminiscences of the American Revolution in the South. Walker and James, Charleston, 1851.

Kimball, Fiske, M.Arch., Ph.D., and Edgell, George Harold, Ph.D. A History of Architecture. Harper and Brothers, New York and London. [1918.]

Le Moyne, Louis Valcoulon. Country Residences in Europe and America. G. P. Putnam's Sons, New York and London, 1921.

Major, Howard, A. I. A. The Domestic Architecture of the Early American Republic. The Greek Revival. J. B. Lippincott, Philadelphia, 1926.

Mills, Robert, Statistics of South Carolina. Hurlbut and Lloyd, Charleston, 1826.

Ramsay, David. History of South Carolina (1670-1808). Duffie, Newberry, S. C., 1858.

Ravenel, Mrs. St. Julien. Charleston, the Place and the People. The Macmillan Company, New York, 1929.

Salley, A. S., Jr. Stub-Entries to Indents for Revolutionary Claims. The State Company, Columbia, 1915.

Simons, Albert, A. I. A., and Lapham, Samuel, Jr., A. I. A. Charleston, South Carolina. Press of the American Institute of Architects, Inc., New York, 1927.

Smith, Alice R. Huger, and Smith, D. E. Huger. The Dwelling Houses of Charleston, South Carolina. J. B. Lippincott, Philadelphia, 1917.

South Carolina Historical and Genealogical Magazine, Charleston. Volume I, *et seq*.

Southern Literary Journal, Charleston, 1836. Volume I.

Stoney, Samuel Gaillard. Plantations of the Carolina Low Country. Carolina Art Association, Charleston, 1938.

Stratton, Arthur. Elements of Form and Design in Classic Architecture. Charles Scribner's Sons, 1925.

Tallmadge, Thomas E., F. A. I. A. The Story of Architecture in England. Harper and Brothers, New York and London, 1928.

NEWSPAPER SOURCES

Charleston Courier, files.

City Gazette and Commercial Daily Advertiser, Charleston, files.

News and Courier, Charleston, files.

South Carolina Gazette, Charleston, files.